A MARINE ARTIST'S
PORTFOLIO

THE NAUTICAL PAINTINGS of SUSANNE FOURNAIS

A MARINE ARTIST'S
PORTFOLIO
THE NAUTICAL PAINTINGS of SUSANNE FOURNAIS

Susanne Fournais Grube

PEN & SWORD
TRANSPORT

AN IMPRINT OF PEN & SWORD BOOKS LTD.
YORKSHIRE – PHILADELPHIA

First published in Great Britain in 2018 by
PEN & SWORD TRANSPORT
An imprint of
Pen & Sword Books Ltd
Yorkshire - Philadelphia

Copyright © Susanne Fournais Grube 2018

ISBN 9781473896338

Printed and bound by Replika Press Pvt. Ltd.
Design: Paul Wilkinson

Pen & Sword Books Limited incorporates the imprints of Atlas,
Archaeology, Aviation, Discovery, Family History, Fiction, History, Maritime, Military, Military
Classics, Politics, Select, Transport, True Crime, Air World, Frontline Publishing, Leo Cooper,
Remember When, Seaforth Publishing,
The Praetorian Press, Wharncliffe Local History, Wharncliffe Transport,
Wharncliffe True Crime and White Owl.

For a complete list of Pen & Sword titles please contact
PEN & SWORD BOOKS LIMITED
47 Church Street, Barnsley, South Yorkshire, S70 2AS, United Kingdom
E-mail: enquiries@pen-and-sword.co.uk
Website: www.pen-and-sword.co.uk

Or

PEN AND SWORD BOOKS
1950 Lawrence Rd, Havertown, PA 19083, USA
E-mail: Uspen-and-sword@casematepublishers.com
Website: www.penandswordbooks.com

Introduction

Coming from Denmark, the sea has always played an important part in my life. The country – aside from the Jutland peninsula – comprises an archipelago of more than 400 islands, some small and some big, that nestle from the Baltic Sea to the Skagerrak. Whilst many of the busier crossings – such as those linking the island of Funen with Zealand and Jutland – have now been provided with bridges, it is only comparatively recently that these were not served by ferries. Many of the smaller islands, however, are still only connected by boat.

The Danes have always been mariners; the Vikings were great explorers and, through them, Denmark came to dominate the north Atlantic. The Orkneys, Shetlands, Faroes, Iceland and Greenland all have a long association with Scandinavia in general and Denmark in particular. The Viking raiders brought terror to much of Britain, but left a rich inheritance in terms of language, culture, place names and people; 1,000 years after Danish monarchs sat on the throne of England, it is still possible to trace bloodlines that owe their origins to these Viking marauders and settlers.

As a nation without many natural resources, Denmark has also been forced to trade; it is no accident that a number of Danish shipping lines are amongst the most significant in the world today. The sea did, however, provide one great resource – fish – and countless coastal communities relied upon this to provide their living. Today, oil, gas and renewable wind energy have increased the importance of the sea to us Danes. The close relationship between these communities and the sea is reflected in the tradition of placing models of ships in many parish churches in the country.

I've been very fortunate in being able to demonstrate this love of and fascination in the sea and shipping through art. Much of my work is represented by private commissions, but I'm lucky enough to be able to devote time to painting those subjects that I find of interest as well. These paintings form the basis of this book.

Although my marine paintings have been exhibited, most recently at a gallery in London, I had never thought that they could form the centrepiece of a book. That they are doing so is down to a chance conversation at a book launch held in the Danish Embassy in London. One of the guests was John Scott-Morgan, Pen & Sword's Commissioning Editor for transport titles, and he saw a number of my paintings on the wall. Impressed by what he had seen, he and I talked about the possibility of putting a book together. The timetable was tight – my husband's posting as Danish ambassador to the Court of St James' was drawing to a close - but the process has been enjoyable. I've revisited a number of paintings that I had put to one side, endeavouring to produce a balanced book reflecting the various themes that I wished to cover. The book that follows comes in six distinct sections, each of which has a short introductory essay outlining the background to the theme and setting the scene.

A book is always a co-operative venture and I'd like to take this opportunity of placing on record my thanks to the various people who have assisted me in its compilation. I've already thanked John; without him, the book would never have progressed and I'm grateful to him for navigating it through to publication. I would also like to express my thanks to Keith Wesley for his excellent photographs, to Peter Waller for assisting with the text, and to my husband, who brought me to this wonderful country which is so closely connected to my homeland, Denmark, by the sea.

Susanne Fournais Grube,
London,
August 2018

Liberty ships

MY PAINTING TECHNIQUES

I USE WOODEN framed canvasses, made from linen/cotton. The canvas is coated with several coats of Gesso, after which the outlining takes place, using crayon to produce the sketches.

I use Acrylics to paint the portraits from a palette of prime, as well as earthy, colours (Umber, Sienna, Ochre). The paintings always carry two or three layers of colour. After drying, they are coated with a satin finishing varnish. Acrylics are not the easiest medium to paint in, as it dries extremely quickly. Acrylic colours change when drying, but if you are organised and quick enough, you can get surprising results from this medium. I never really know what the final result might be due to the changes that take place during the drying of the paint. If I am not happy with the result, I will change the colour until I feel satisfied.

You would be surprised as to how many coats of paint are used on my canvasses to obtain the final result, all because of a slight colour change.

The name says it all: Liberty. At a time when the free world was under threat and when countless thousands were dying as the German submarines sank vast quantities of shipping, it was the mass-produced Liberty ships that maintained the essential link which kept Britain in the war. Without the huge quantities of food, raw materials and military equipment shipped across the Atlantic by these basic freighters, the country would not have been able to survive; Hitler's aim of starving Britain into submission would have succeeded and the modern world would have been a very different place.

Although designed in Britain, the Liberty ships were mass-produced in American shipyards. No fewer than eighteen shipyards across the USA constructed more than 2,700 of the cargo ships between 1941 and 1945, and boy were they needed. For much of the war the success of the German U-boats, operating unrestricted submarine warfare in the Atlantic, resulted in the sinking of more cargo ships than

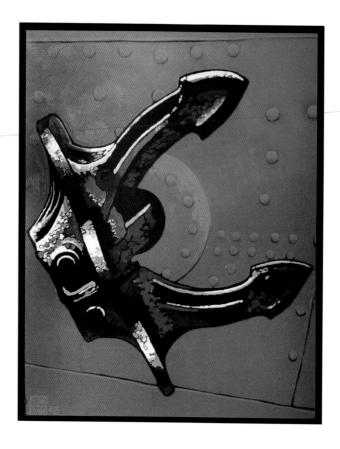

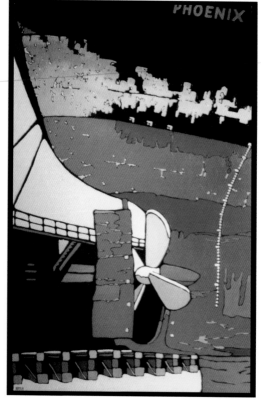

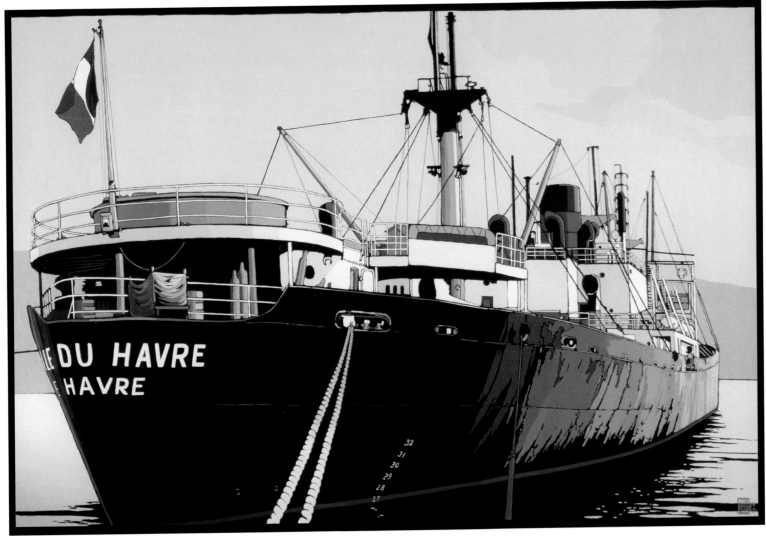

could be manufactured. Pioneering new methods of construction – welding rather than riveting the hulls, for example – meant that the manufacturers were able to produce the Liberty ships at an unprecedented rate. It was possible to get a completely new ship, from the laying of the keel to the launch, in less than a month, and full completion within six weeks; such a rate of production was essential if the staggering monthly losses were to be countered.

It's often a relatively insignificant factor that proves decisive in conflict; without the Liberty ships and their ability to carry vast quantities of supplies across the hazardous Atlantic waters, the course of the war might have been different. What they lacked in style they made up for with a gritty determination to see the job done.

Inevitably, a significant number found themselves casualties of conflict, but more than 2,400 survived the war, although many were quickly scrapped and others mothballed. Others, however, were to find a commercial use in the post-war years; many of the well-known shipping magnates of the second half of the twentieth century made money from buying up redundant Liberty ships and reusing them for commercial trade. Gradually, however, most of these post-war survivors gradually succumbed to the ravages of time and to the inherent dangers of the sea (both natural and man-made). Today only three survivors exist to remind us of the importance of these highly successful cargo ships to the Allied war effort.

VILLE DU HAVRE

LIBERTY I

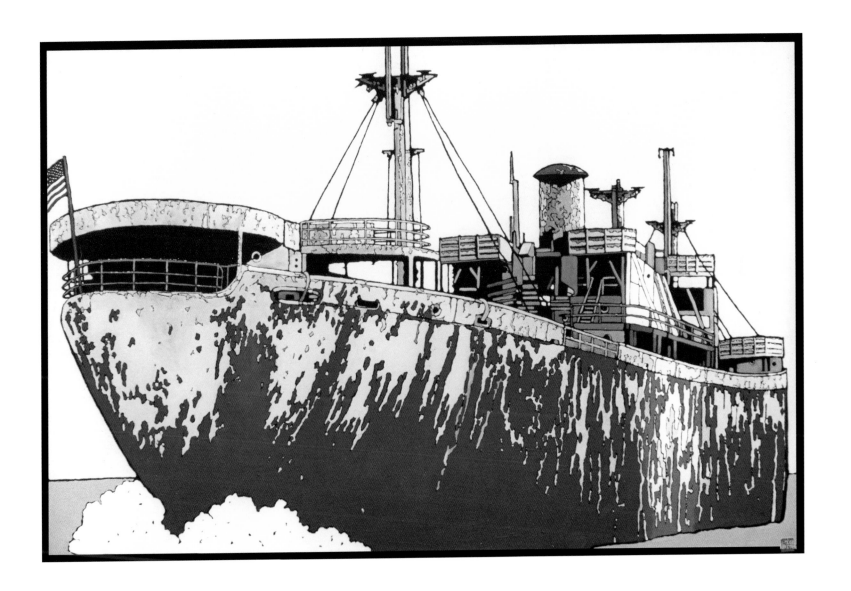

HOPE AND GLORY

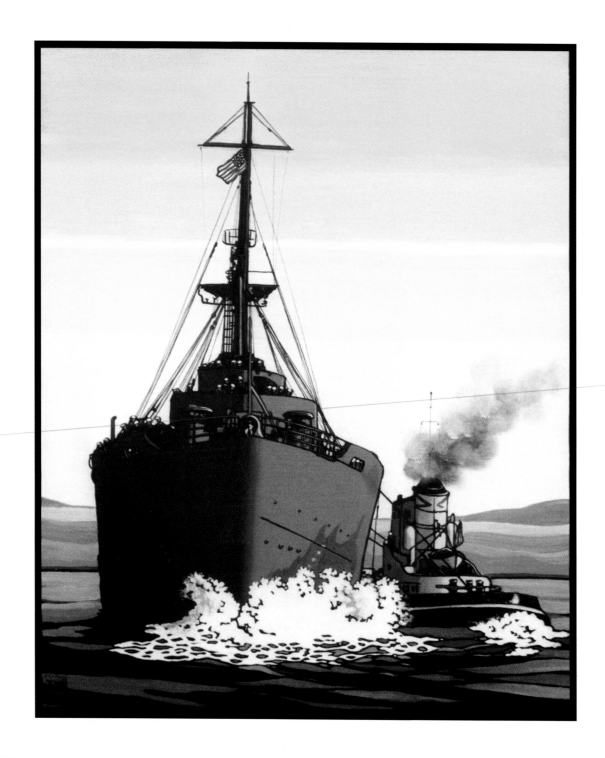

TUG O'WAR

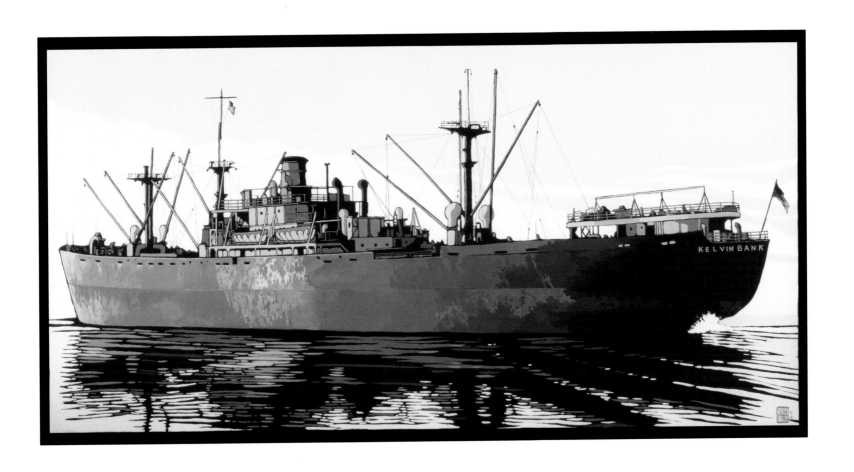

KELVIN BANK

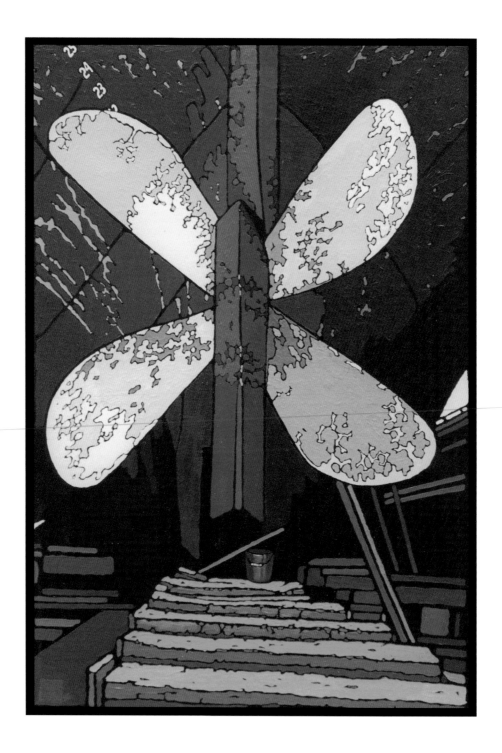

PROPELLER

LIBERTY II

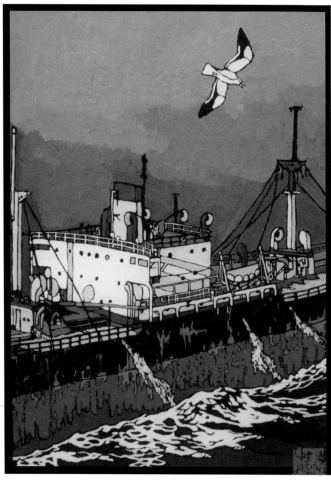

SEA GULL

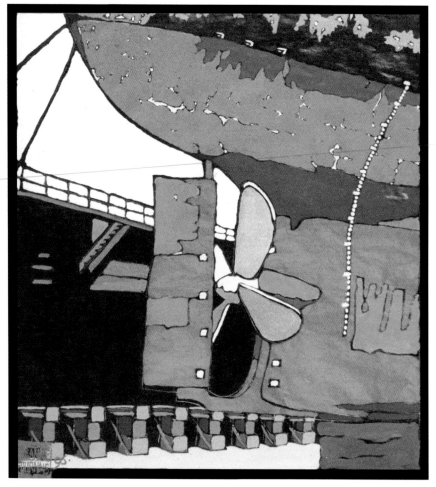

DRY DOCK

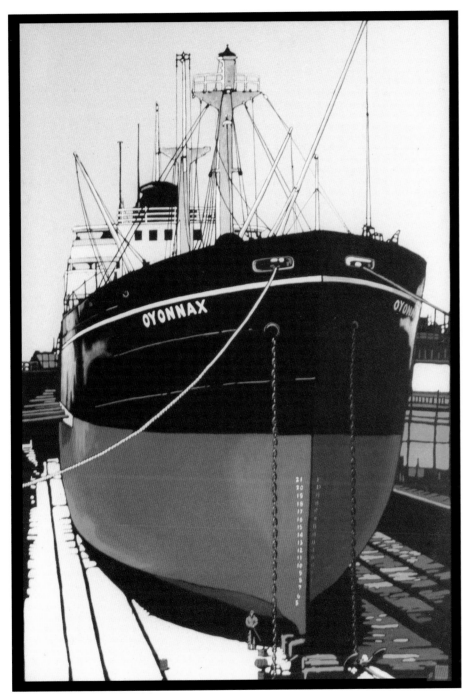

OYONNAX

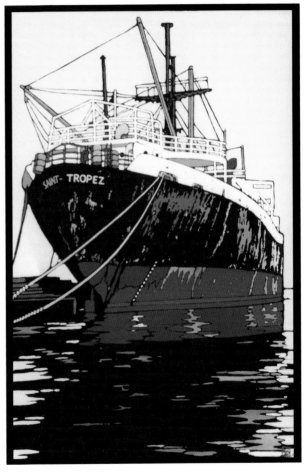

SAINT-TROPEZ

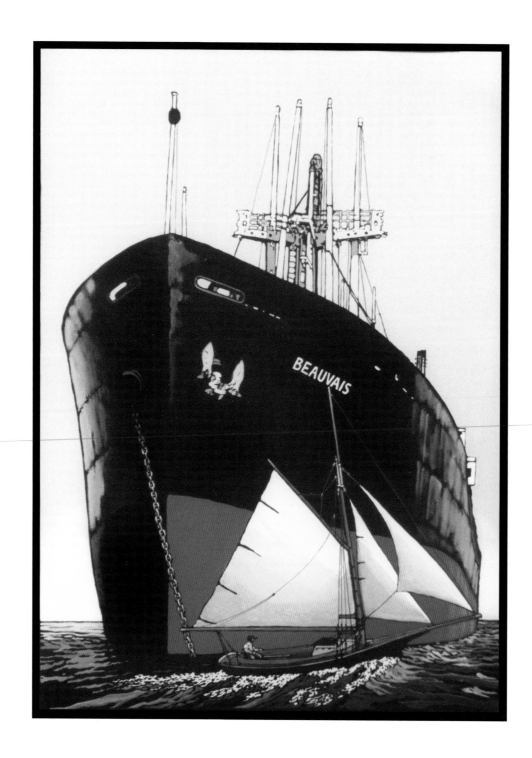

BEAUVAIS

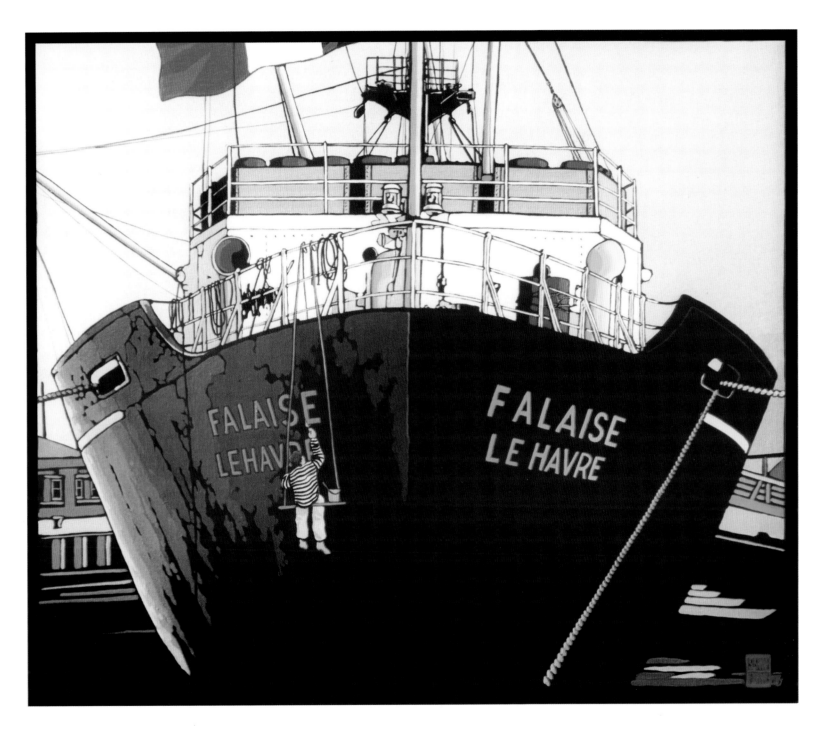

FALAISE

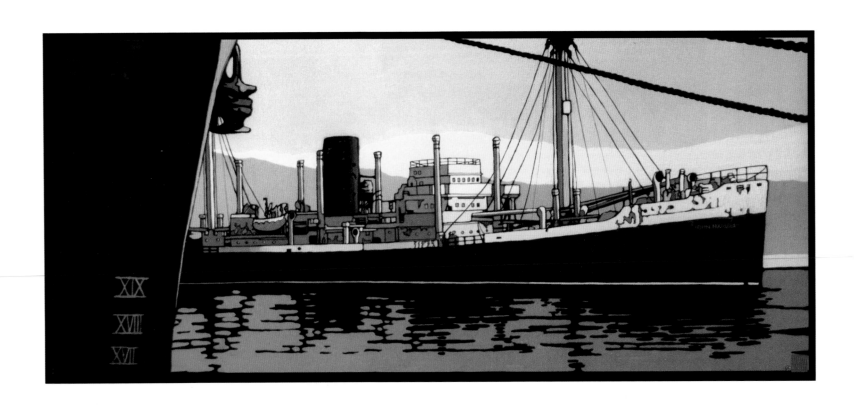

JOHN HARVARD

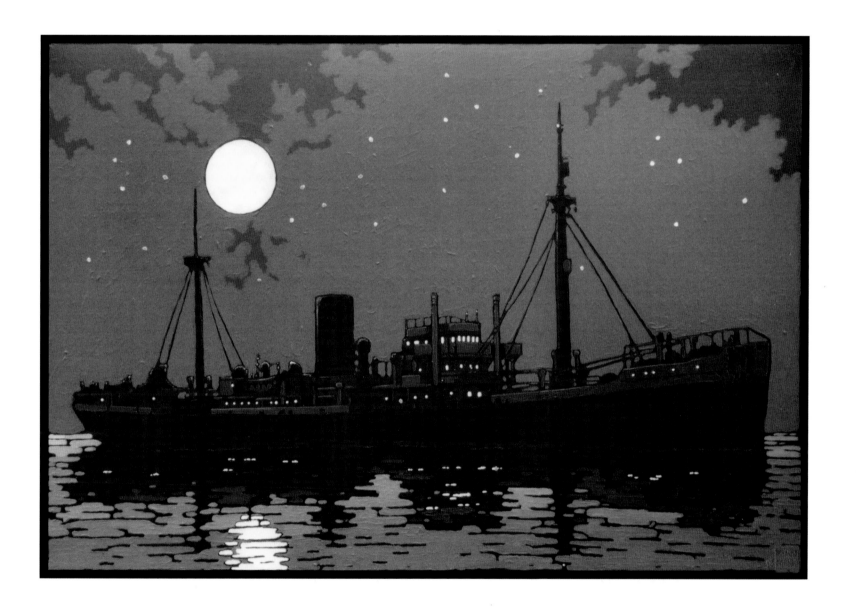

SILENT NIGHT

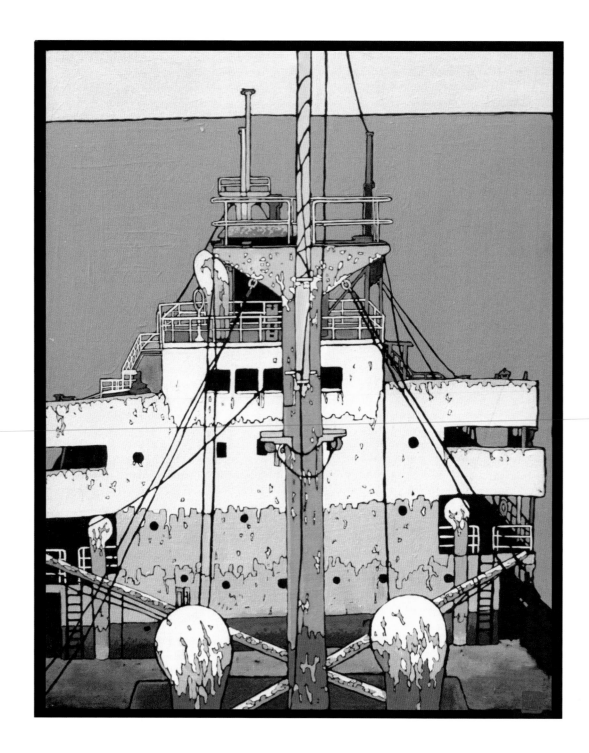

NORTH SEA

Tug boats, ferries and pilots

Over the past 150 years, as a result of the use of iron and steel in construction, the size of ships has grown exponentially. This has had a number of consequences. Many of the traditional ports and harbours, for example, were no longer capable of accommodating the largest cargo vessels, resulting in the construction of new – and larger – facilities. Moreover, as the size of ships has grown, they have also become less manoeuvrable and the channels that they can navigate through have become more restricted.

Although there were examples of rowed vessels acting to assist ships in harbours, it was the use of the steam engine that facilitated the development of the tug into a self-propelled and easily manoeuvrable vessel. From the late nineteenth century onwards, ports like Liverpool, Southampton and London witnessed increasing numbers of steam-powered tugs to cater for the vast and increasing number of ships that plied their trade moving goods and raw materials across the globe. With the invention of the internal combustion engine, steam was gradually replaced by diesel as the primary means of propulsion.

Tugs and pilot boats come in many different guises. The most familiar, and the types of tug normally seen around the main ports and harbours, are the relatively small vessels – short but broad with a shallow draft – that are used to guide larger ships up narrow estuaries, or to manoeuvre these larger ships safely to their moorings. These tugs are designed for operating exclusively in coastal and shallow waters, or in their home port. At the other extreme are the larger ocean-going tugs. These are designed

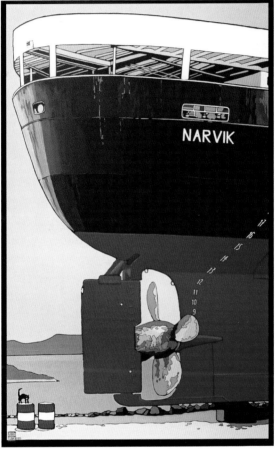

to venture far beyond the coastal waters, often towing barges, and are capable of dealing with the high seas.

In an era before roads and railways existed, rivers and seas represented the primary means of human communication. Whilst most people now travel by car, train or aircraft, there still remains one common mode of transport for traversing water: the ferry. Where it is impractical to construct a bridge, or where the journey is too short to justify an air link, the ferry offers a practical and cost-effective means of communication.

For an island nation like Britain, or a country like Denmark that comprises in part an archipelago of islands, the ferry has traditionally represented an essential link between the constituent parts of the country. The ferries might cross wide river estuaries – such the now-lost links across the rivers Forth, Humber and Tay – or between the mainland and outlying islands, such as that between Scrabster on the north coast of Scotland and Stromness on Orkney, which crosses the Pentland Firth; reputedly one of the stormiest stretches of water in the world.

In an age before steam or diesel power, many of these ferry links were provided by rowing boats or by small sailing vessels, with all the inherent risks that these entailed. The rise of the steam (and later the diesel) engine saw new routes develop – such as those linking Britain with continental Europe – which facilitated the growing exchange of goods and people across northern Europe.

Initially, ferries were primarily passenger only, but with the rise of the internal combustion engine, vehicle ferries soon came

NARVIK, HURTIGRUTEN

to dominate. These had a limited capacity when they first appeared in the early years of the twentieth century, but have grown in size and sophistication as the number of vehicles wishing to use them has increased. The author remembers well the contrast at the Danish port of Esbjerg between the ferries used on the service to Newcastle and those to Harwich; on the former route, DFDS employed older vessels, where the cars had to be craned on or off and there was no space for lorries or coaches. On the latter, however, where the more modern and larger ferries were used, the roll-on/roll-off principle was employed, making for much faster loading and unloading times, and avoiding the occasional mishap where the car was damaged whilst being loaded into the ferry's hold.

However attractive ferry crossings are, they do impose limitations on the amount of traffic that can be catered for, and add considerably to the journey time. Fixed links – such as bridges or tunnels – are much more efficient. New fixed links such as that across the Oresund between Denmark and Sweden – inspiration for the cult Scandi-noir television series *The Bridge* – or the Channel Tunnel between Britain and France have seen the removal of some traditional ferry services, but not all. Even with the Channel Tunnel, vast numbers still prefer the traditional route between Dover and Calais, seeing the ferry crossing as a welcome break between the motorway trips on either side.

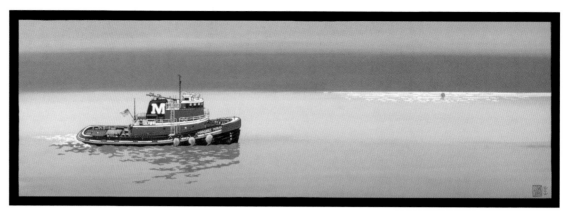

M.MORAN OF N.Y.

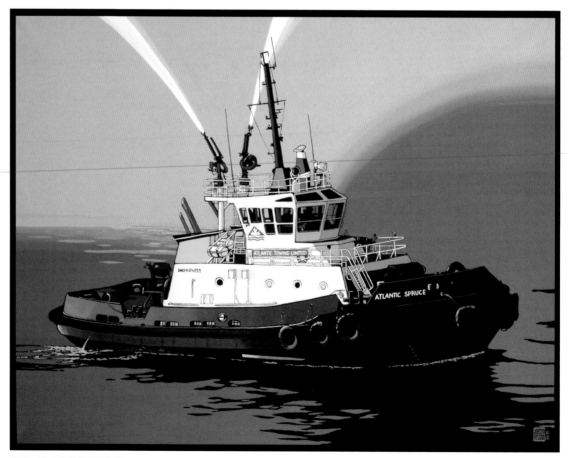

ATLANTIC SPRUCE

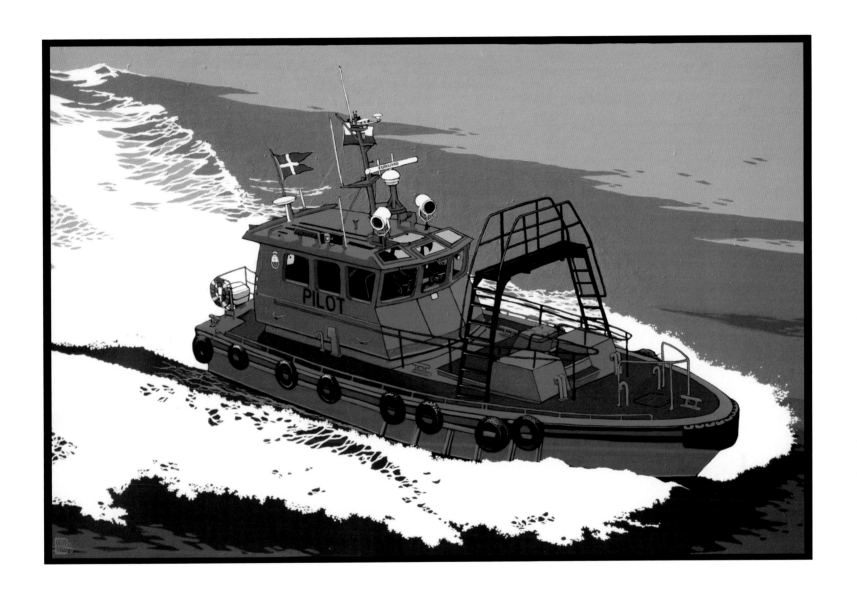

PILOT, KØBENHAVN

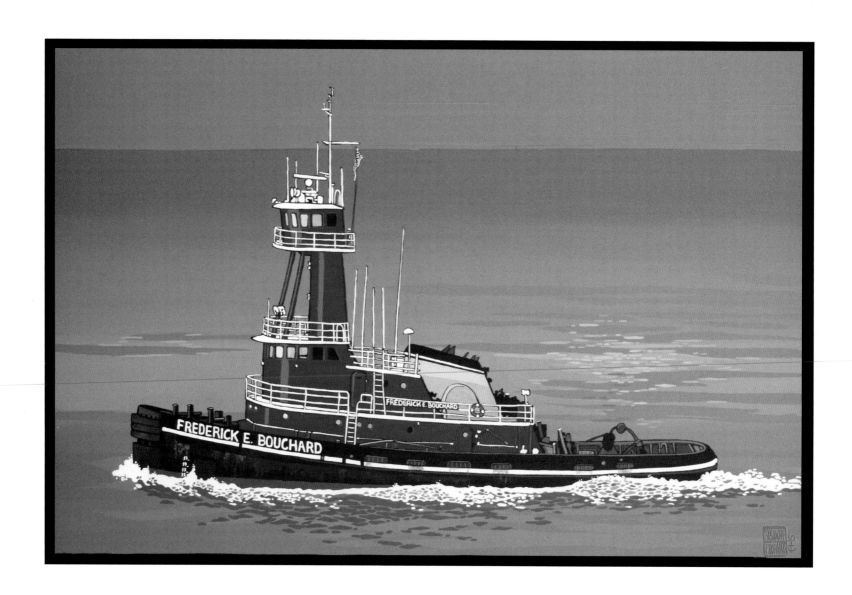

FREDERICK E. BOUCHARD

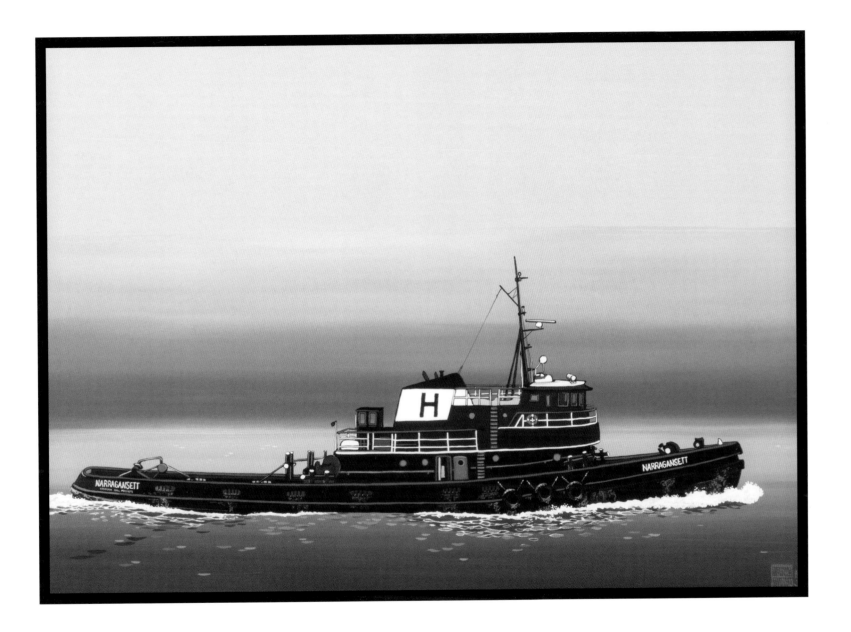

NARRAGANSETT

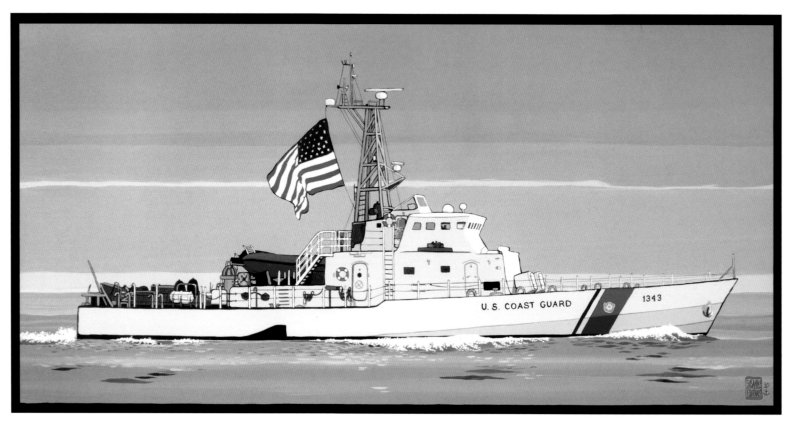

US COAST GUARD

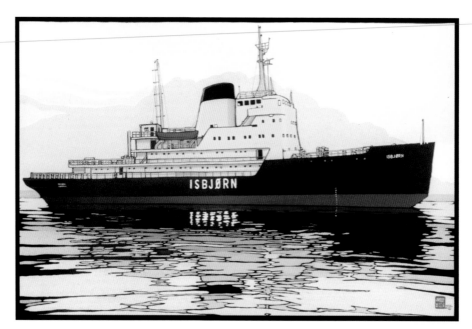

ICEBREAKER ISBJØRN

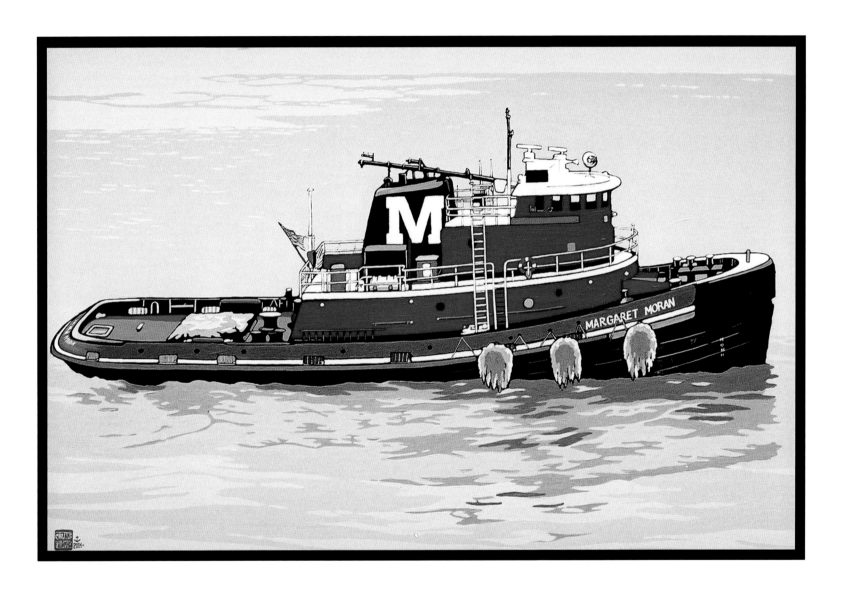

MARGARET MORAN

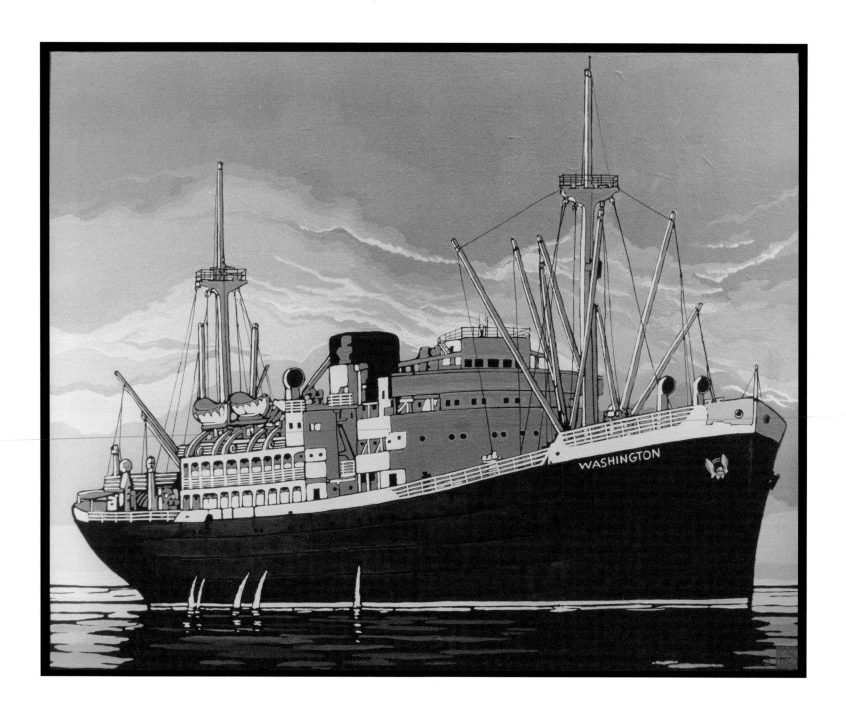

CARGO WASHINGTON

OUT OF AFRICA

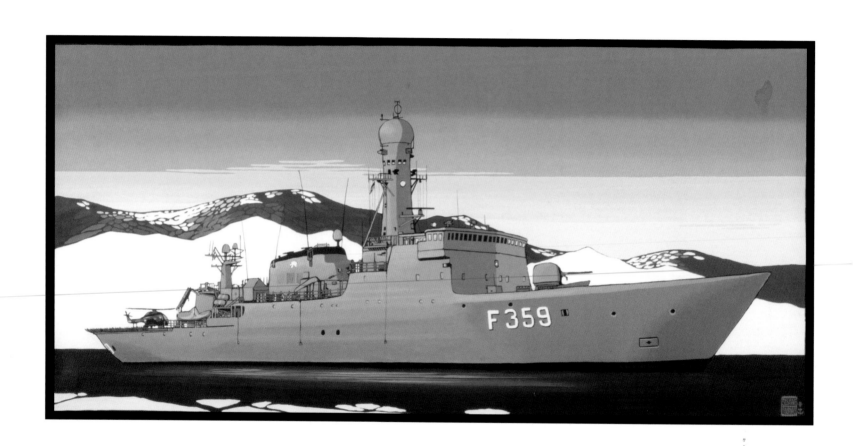

VÆDDEREN

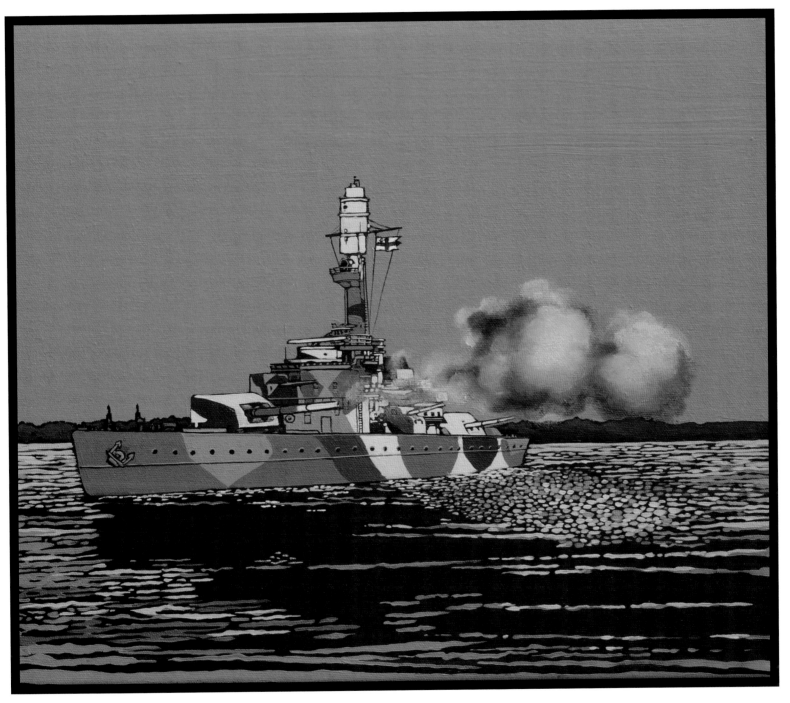

VÄINÄMÖINEN

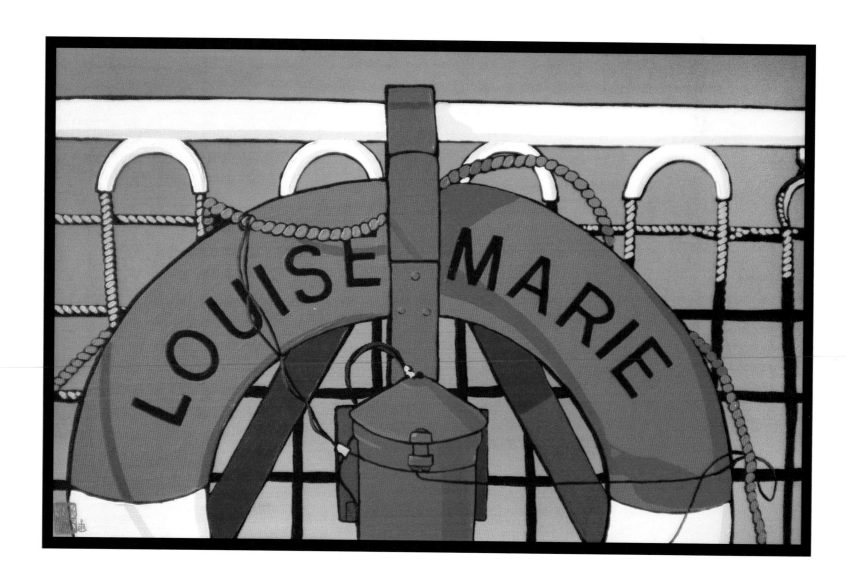

LOUISE MARIE

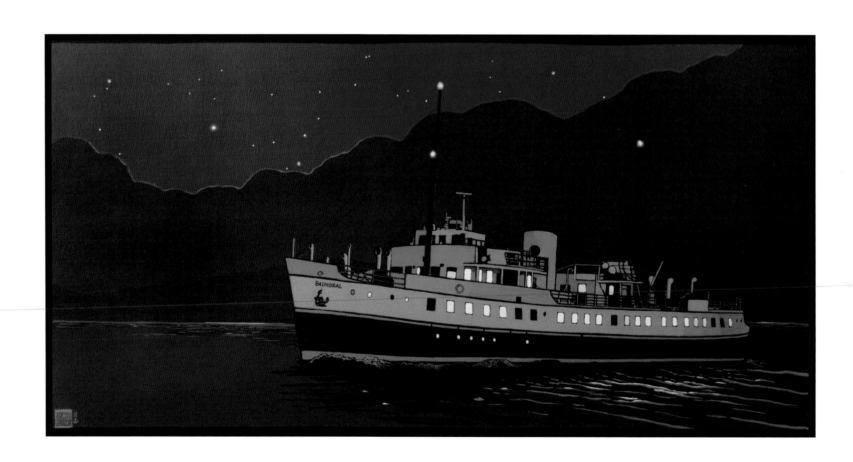

BALMORAL

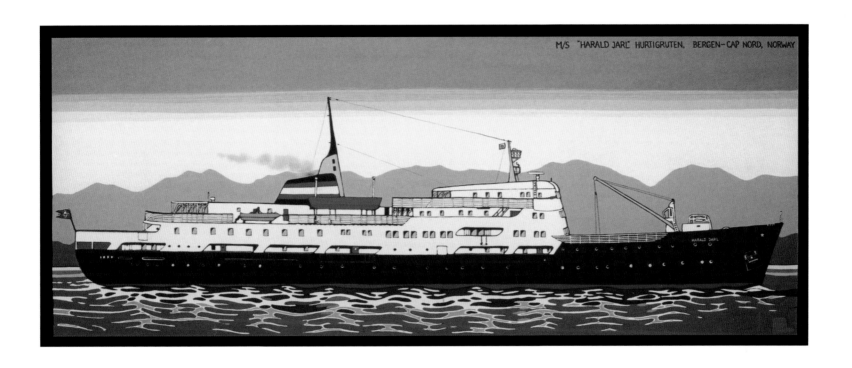

M/S "HARALD JARL" HURTIGRUTEN, BERGEN-CAP NORD, NORWAY

HARALD JARL, HURTIGRUTEN

Ocean Liners

If the tugs and ferries represent the workaday, then the ocean liner provides the sea with its glamour. The romance of names such as *Mauretania, Queen Mary, Queen Elizabeth, Olympic, France* and *Queen Elizabeth 2* is redolent of the golden age of shipping, and an era when the great film stars, sportsmen, politicians and royalty travelled the globe on-board the great liners.

The history of the liner effectively stretches back to the early nineteenth century and the development of the packet ships; these were sailing ships that were primarily designed to carry mail and passengers for the first time according to a timetable. However, like all sailing ships, these vessels were subject to the vagaries of the weather and it was not until later in the century that, with the use of iron and steam, the great liner revolution began. The great but mercurial British engineer Isambard Kingdom Brunel was at the forefront of these developments, with his majestic trio of liners completed in the twenty-one years from 1838 to 1859: the SS *Great Western*, the SS *Great Britain* and the SS *Great Eastern*. It was in 1840 that one of the great names of the north Atlantic trade route, Cunard, commenced its operations, with others such as White Star Line following, sparking a competition for speed and luxury that was to have tragic consequences in April 1912, when the supposedly unsinkable RMS *Titanic* came to grief amidst the spring icebergs.

The north Atlantic route was undoubtedly the most glamorous; rival shipping lines competed with each other to gain the coveted 'Blue Riband' for the fastest crossing, either east- or west-bound. For the celebrities of the period, who could afford the luxury of first class, there was no more prominent way to arrive than on-board one of the great liners that plied their trade across the Atlantic. But there were other routes as well, to Africa, India and Australia which, for the British,

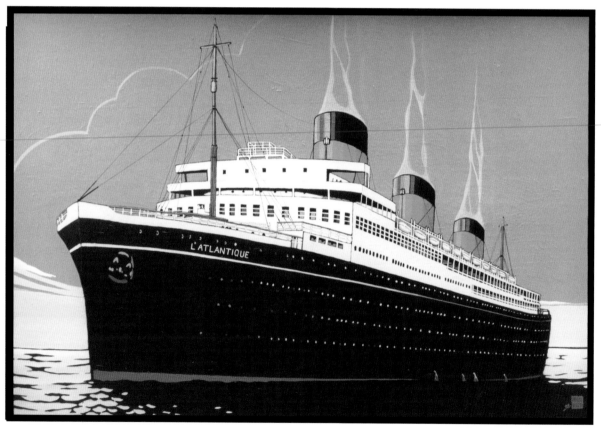

L'ATLANTIQUE

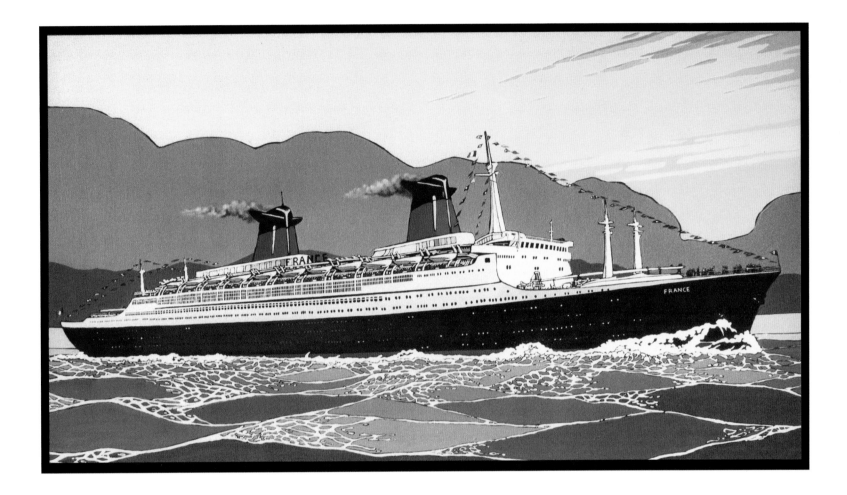

provided connections to and from the most important parts of its global empire.

It was inevitable that the original golden age of the liner would disappear; the rise of air travel – particularly with the success of the jet engine and the increasing size of aircraft – meant that the many thousands of non-first class passengers – always the bread and butter of even the most glamorous liners – now had quicker and cheaper means of crossing the Atlantic. One by one the great names disappeared; the RMS *Queen Mary* was sold to California, where she remains as a tourist attraction, whilst the RMS *Queen Elizabeth* came

to an ignominious end in Hong Kong harbour after being consumed by fire. Even the last great liner built in Britain, the RMS *Queen Elizabeth 2* no longer plies its trade.

But there is a new golden age; the massive growth in cruising has witnessed the construction of impressive new cruise liners. With their vast capacity and facilities, they are undoubtedly more floating hotels rather than the stylish ships of the interwar years, but cruise ships like the RMS *Queen Mary 2* and the MS *Queen Victoria* ensure that in the early years of the twenty-first century, it is still possible to traverse the oceans in a most civilised way.

FRANCE

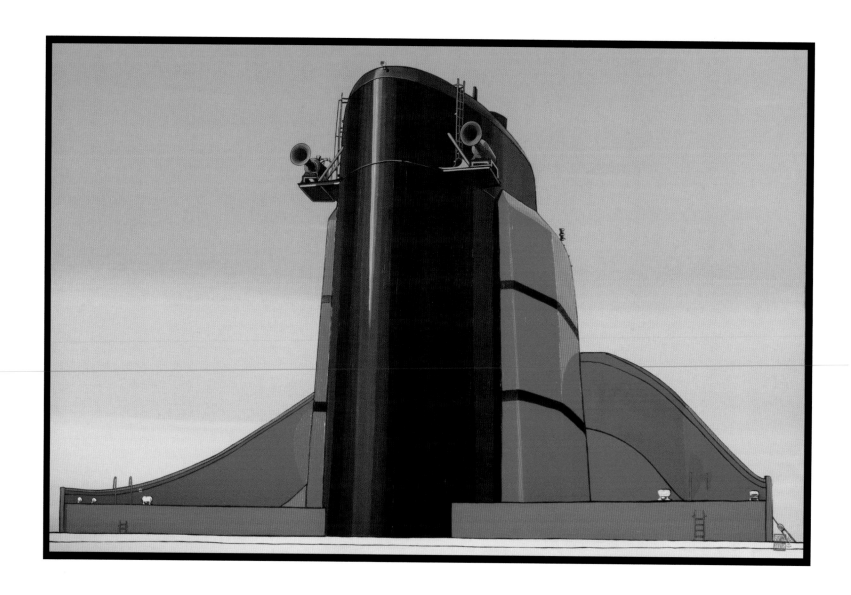

QM2 FUNNEL

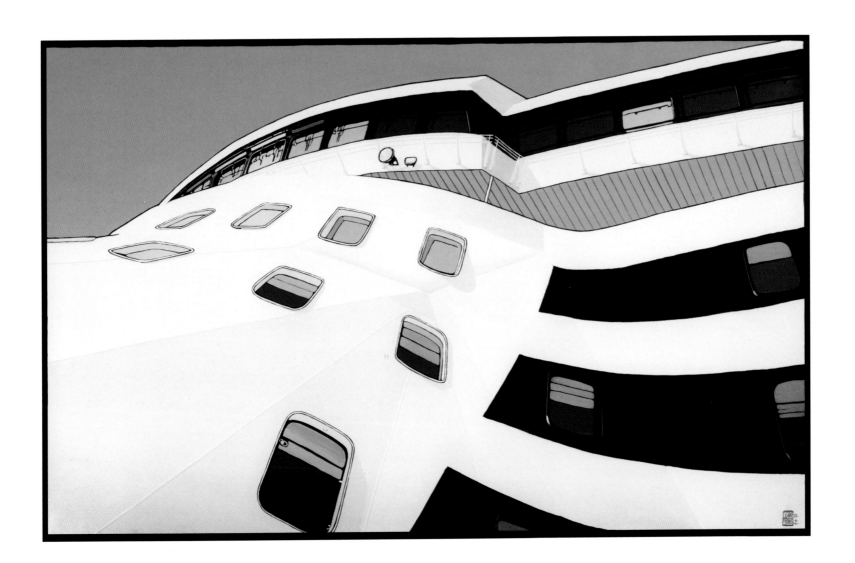

QM2 FRONT

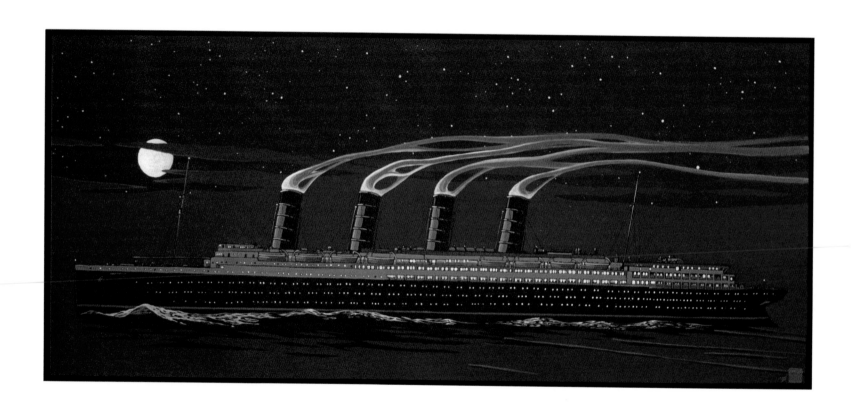

LUSITANIA

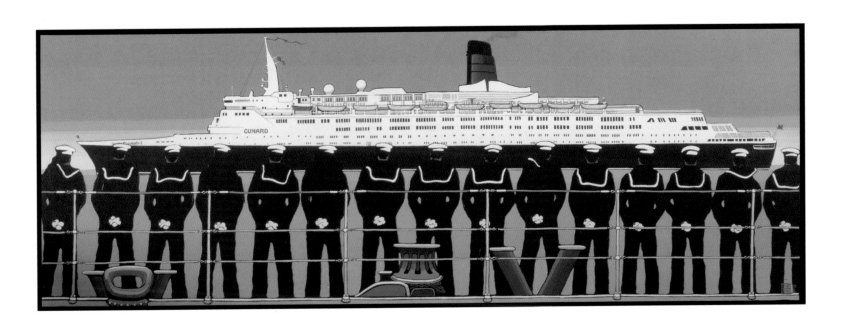

FAREWELL QE2

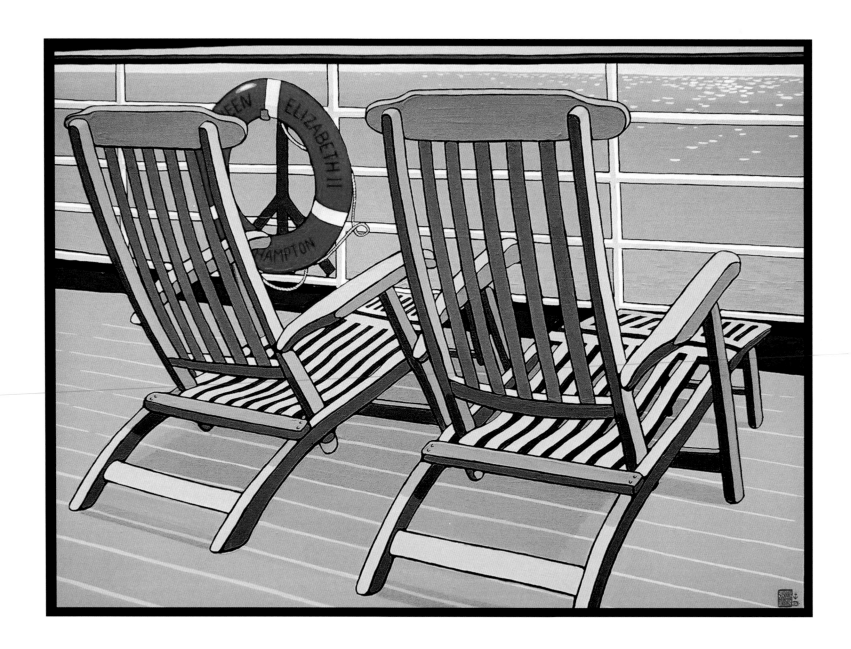

QE2 DECK CHAIRS

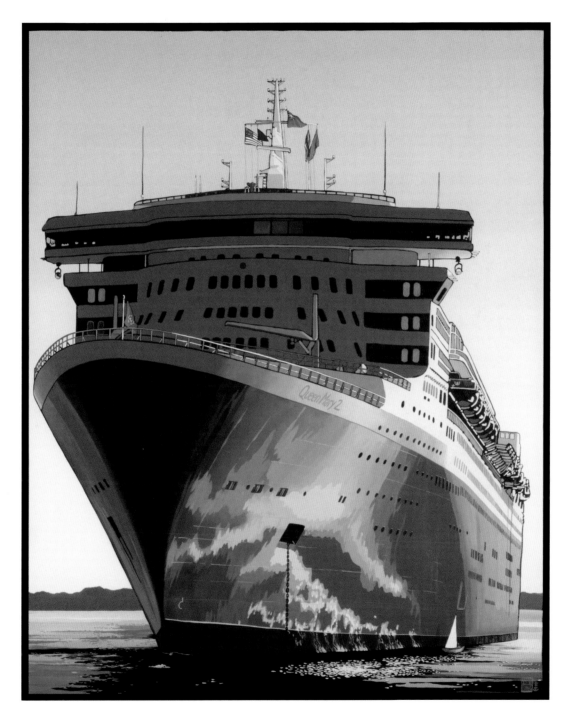

QM2 NEWFOUNDLAND

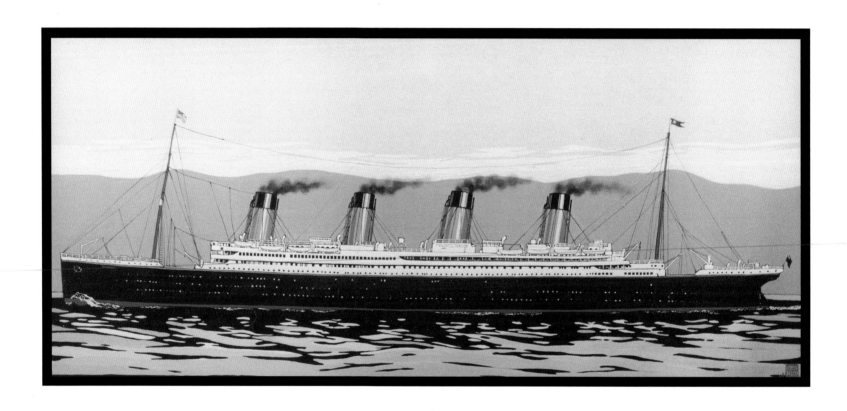

RMS TITANIC

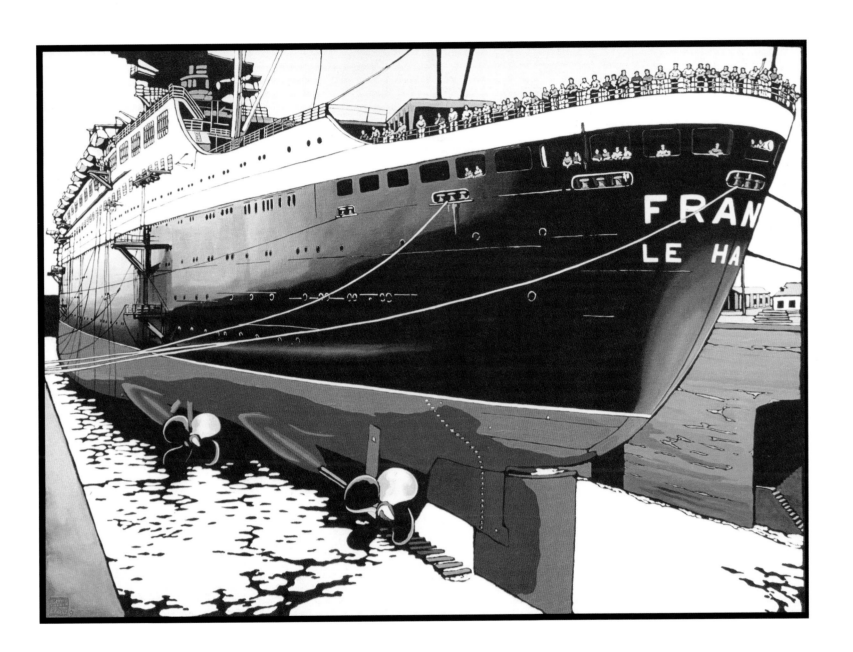

LAUNCHING OF THE FRANCE

MAURITANIA

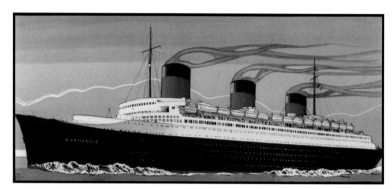

NORMANDIE

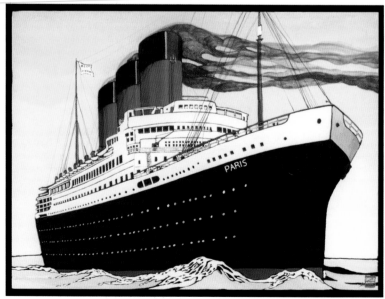

PARIS

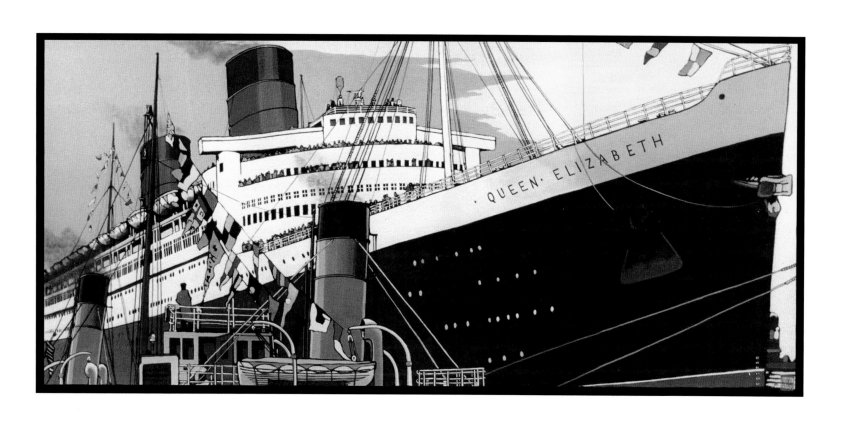

Super tankers

Ultimately, the vast bulk of shipping in the modern age concerns trade and commerce: the movement of raw materials and finished goods from suppliers to customers. At any one time the world's major shipping lanes are full of vessels transporting freight from one port to another. In an increasingly global economy, these massive ships offer true economies of scale and are an essential part of modern commerce. Amongst the commodities carried widely by these massive vessels are oil and various other types of hydro-carbons, both crude and refined.

In 1954 Shell Oil developed the Average Freight Rate Assessment, which was designed to classify tankers of different sizes. At the time, the largest tankers afloat were in the range of 45,000-80,000 DWT (deadweight metric tonnage). However, this all changed in 1956. Prior to that date, all tankers had been designed with a maximum size based upon the capacity of vessels that made use of the Suez Canal, due to the fact that most oil shipments were from the Persian Gulf bound for Europe. However, the Suez Crisis of that year, which resulted in the controversial Anglo-French invasion of the canal zone, resulted in the closure of the canal and the movement of oil products via the longer Cape of Good Hope route. The shippers realised that despite the longer distance, the Cape route offered greater economies as the size of ship – and thus the quantity of freight carried – could be massively increased.

As a result the trend towards the construction of ever-larger super tankers began. Today, under the notation of the Average Freight Rate Assessment, there are two categories of super tanker: the Very Large Crude Carrier (VLCC) from 160,000-319,999 DWT and the Ultra Large Crude Carrier (ULCC) in the range from 320,000-549,999 DWT. The largest super tanker ever constructed was the *Seawise Giant*. This leviathan was built in Japan in 1979 and came in at a whopping 564,763 DWT. Such was the bulk of this tanker that it could not sail through the English Channel when fully laden. Currently, the two largest super tankers in service both have a capacity of 441,500 DWT and a cargo capacity of over 3 million barrels. The epic scale of these vessels can be indicated by the fact that in 2009, Britain consumed about 1.6 million barrels of oil per day.

The scale of these super tankers leads to a major problem: when

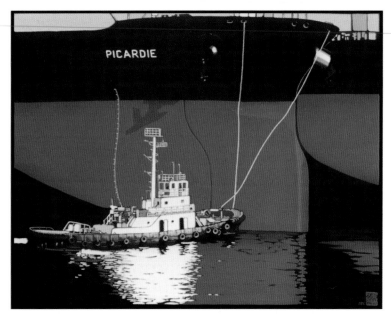

PICARDIE

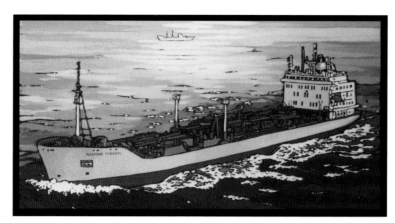

RASMINE MÆRSK

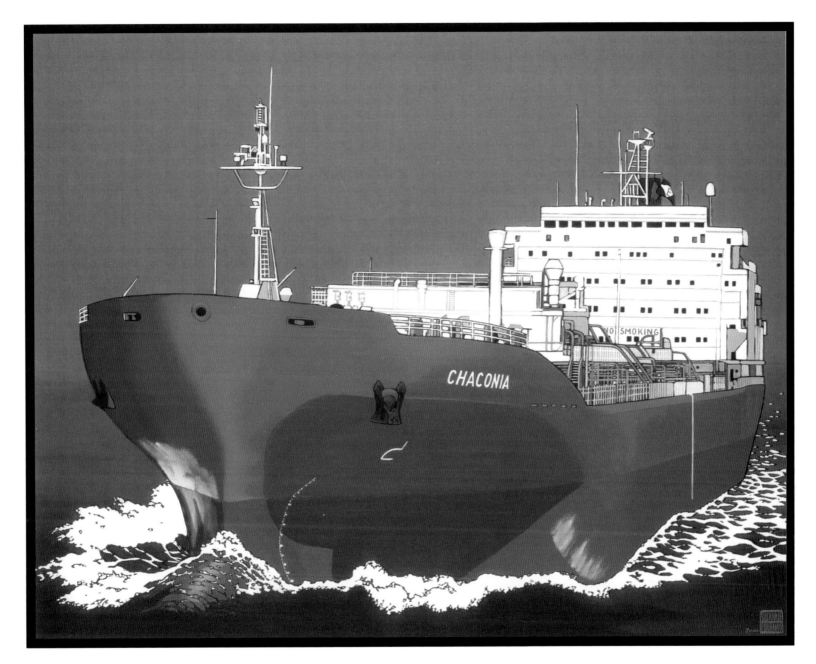

fully loaded, they are too large to use many of the existing dock and port facilities . Whilst they can be loaded at off-shore facilities, at their destination ports they often dock off-shore and transfer their cargo to smaller tankers for onward movement to the refineries and customers on-shore. For Britain, as the North Sea reserves of oil and, more particularly, natural gases decline, so the number of these vessels serving the country will increase as liquefied natural gas (LNG) comes in as a replacement.

CHACONIA

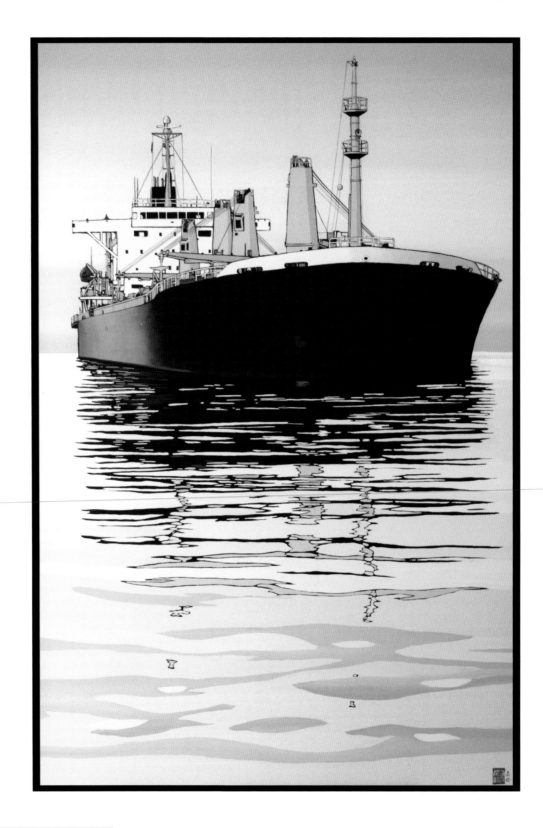

NORDEN

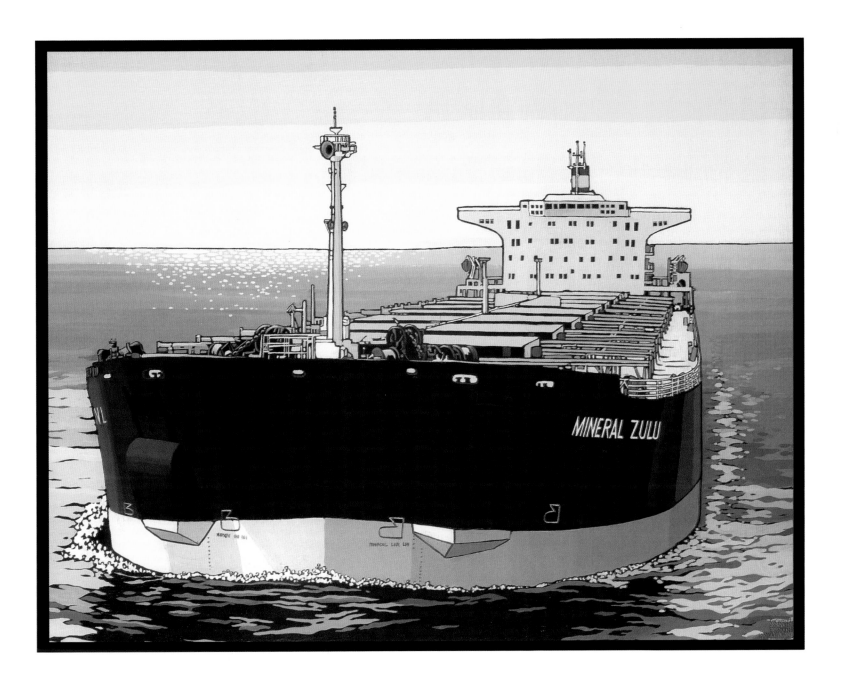

MINERAL ZULU

TORM

NO SMOKING!

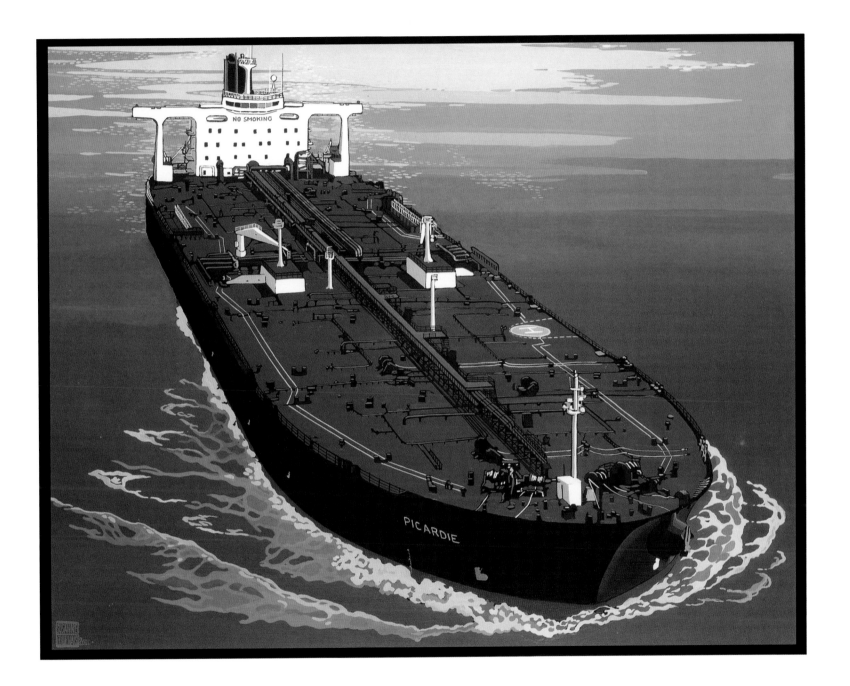

PICARDIE

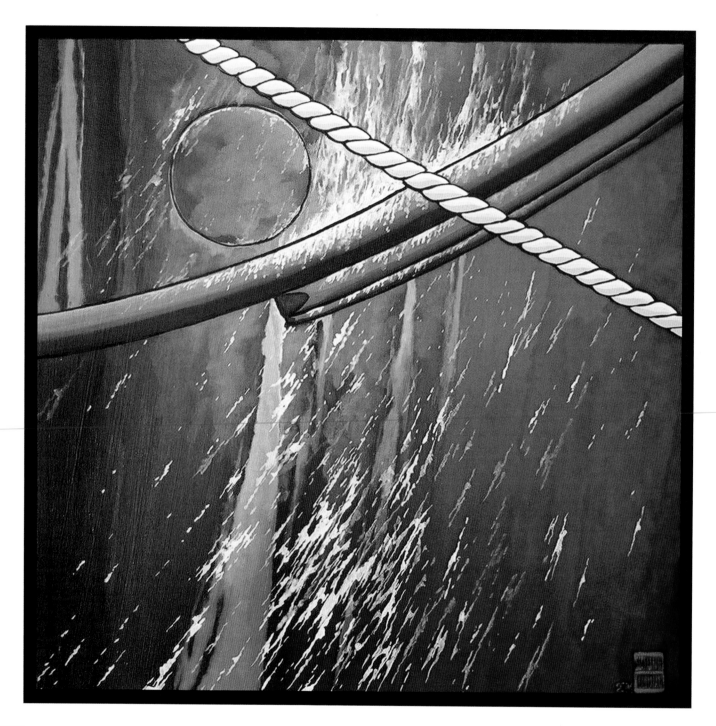

FAEROE

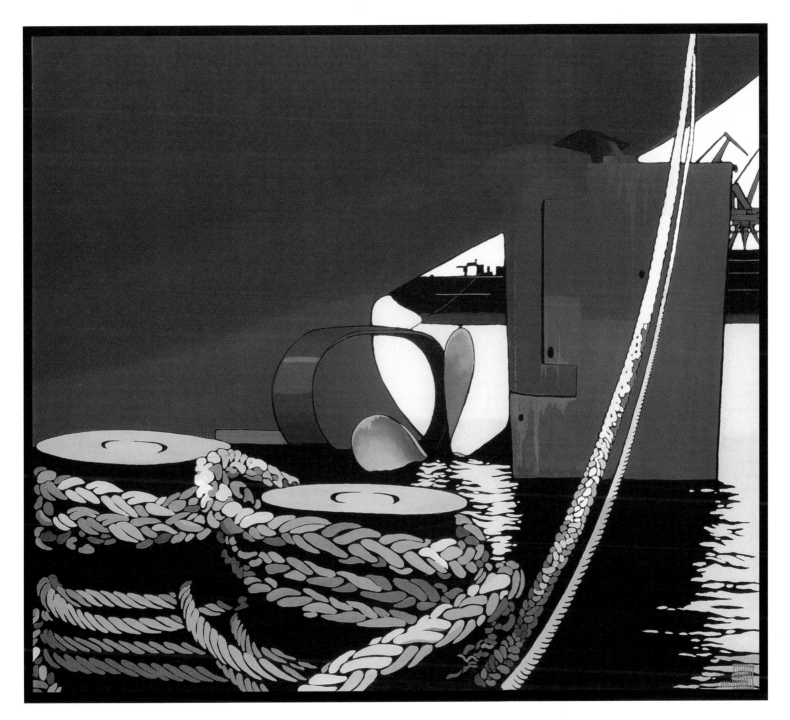

CMB

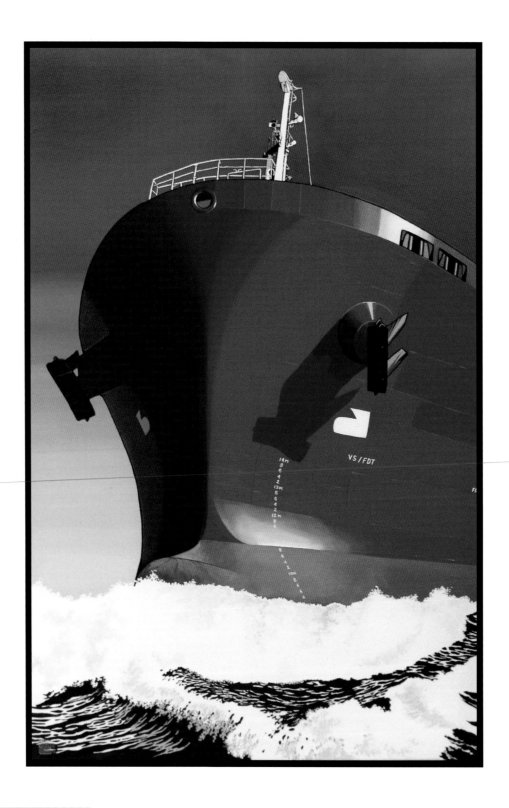

LAURITZEN

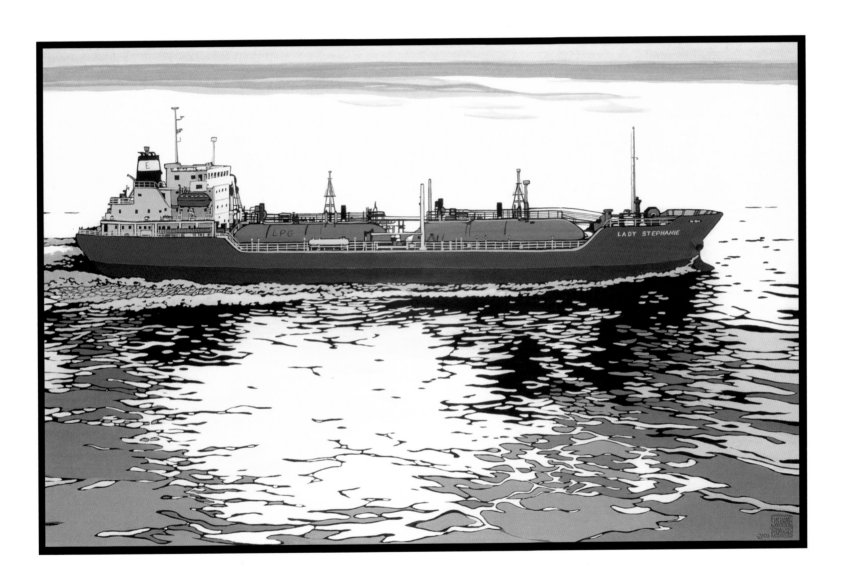

LADY STEPHANIE

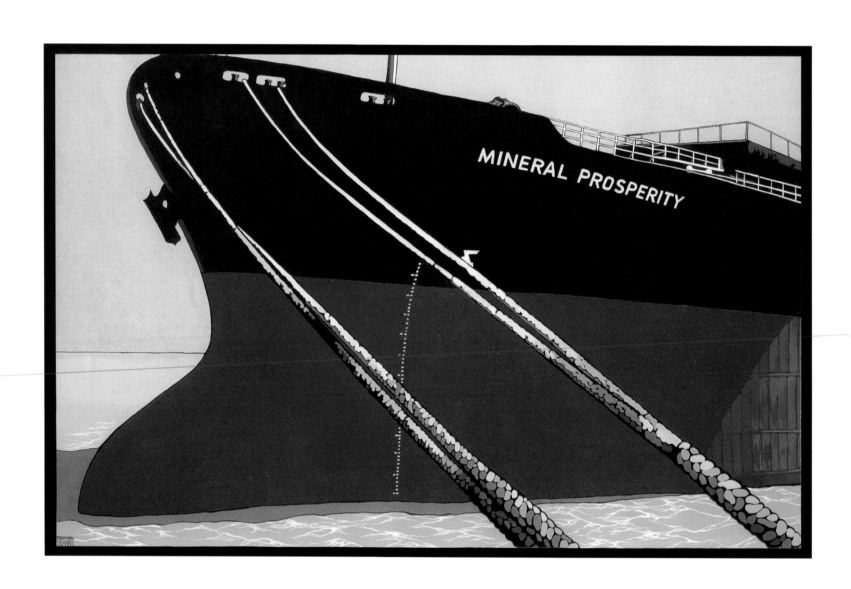

MINERAL PROSPERITY

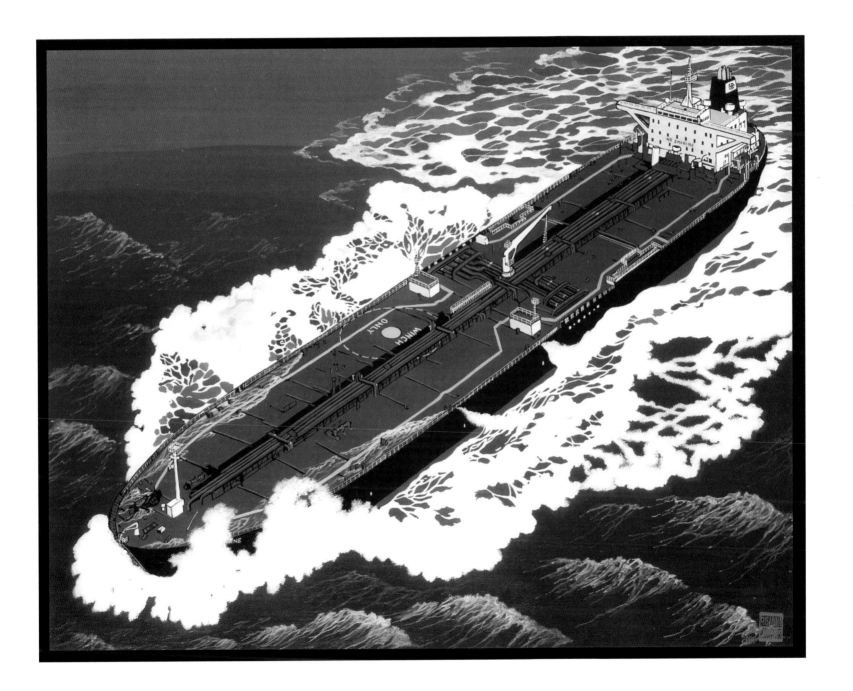

Lighthouses

The sea can be benign; it can also be amongst the most treacherous of environments for those who are forced to venture onto it for work, travel or pleasure. In the age of sail, when all who travelled across the oceans were reliant upon the skill of the crew in mastering the prevailing winds, uncharted reefs and rocky coastlines represented a constant threat. It was no accident that one of the seven wonders of the ancient world – the Pharos of Alexandria – was a lighthouse that helped to protect mariners sailing to Egypt by guiding them safely to port.

The earliest form of protection or guidance for sailors was primitive, often comprising of no more than a simple fire visible only over a short distance, which was virtually useless in poor weather conditions. The visibility could be improved slightly by raising the fire higher on a platform, but this did little to strengthen the signal. At sea, until the development of the modern lighthouse, the sailor was undoubtedly at the mercy of the elements and reliant upon the

skill of the navigator in ensuring the ship followed – as far as was possible – the safest channels.

It was around 1700 that the first attempts to construct more powerful lighthouses were undertaken. The most famous of these pioneering lighthouses was that constructed by Henry Winstanley on the Eddystone Rocks between 1696 and 1698. Largely constructed in timber, but with iron stanchions, the Eddystone Lighthouse was the first in the world to be fully exposed to the sea. And the sea, if piqued by Winstanley's effrontery, rapidly took revenge; the Great Storm of 7 December 1703, which witnessed massive destruction in much of southern England, also saw the demise of the Eddystone Lighthouse and the death of its builder, who had the misfortune to be visiting the building when the storm arrived.

Although it would not be until the 1750s that a replacement Eddystone Lighthouse was completed, this time built in granite to the design of John Smeaton, the principle of tailor-designed

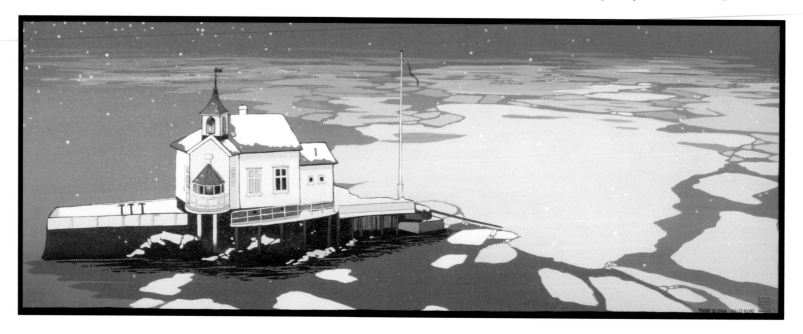

DYNA LIGHTHOUSE

structures had been established. Smeaton's design, the tall but tapered tower with a prominent chamber for the improved lighting, became recognised worldwide. The late eighteenth century witnessed improvements in the lighting technology used, most notably in the Argand lamp invented in 1782 by the Swiss scientist Aimé Argand, which resulted in a much better quality flame without smoke. From the early nineteenth century onwards, a network of lighthouses along the coast of Britain, Europe and further afield grew up, and whilst the basic concept remained the same, each country evolved its own distinct design.

The lighthouse crew – potentially separated from family and friends for months on end – were often a breed apart, with myths and legends commonly told about them. In the poem *Flannan Isle*, first published in 1912, Wilfrid Wilson Gibson describes the mystery of a lighthouse crew that mysteriously disappears, relating to an actual incident of 1900 when all three crewmen vanished without explanation. The automation of many lighthouses has rendered the lighthouse keeper increasingly redundant, but the need for maintenance ensures that organisations such as Trinity House, which is responsible for lighthouses in the British Isles, or the Commissioners of Irish Lights, still send men on perilous missions to places like Eddystone, Bell Rock and Fastnet.

Lighthouses are still an integral part of the maritime environment; standing, for example, on cliff tops, they are a stark reminder of the dangers that the sea still poses. With the amount of technical equipment onboard ships today and with greater reliance on diesel, rather than wind-power, shipping is much safer, but the crews on-board will still be grateful for the foresight of those who developed lighthouses, and for the countless generations of lighthouse keepers who risked their own lives in keeping the shipping lanes open.

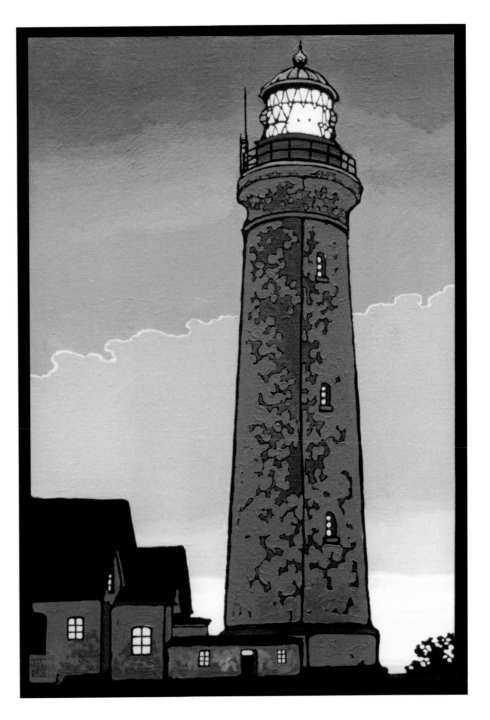

HIRTSHALS LIGHTHOUSE

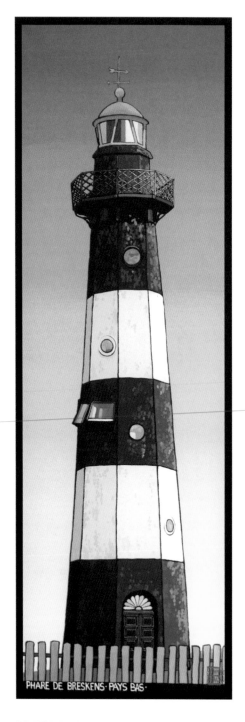

BRESKENS

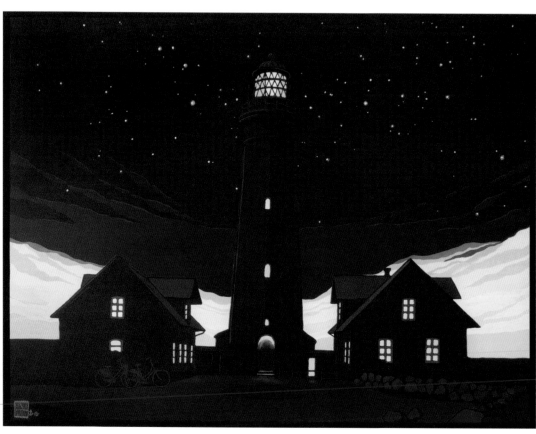

BOVBJERG BY NIGHT

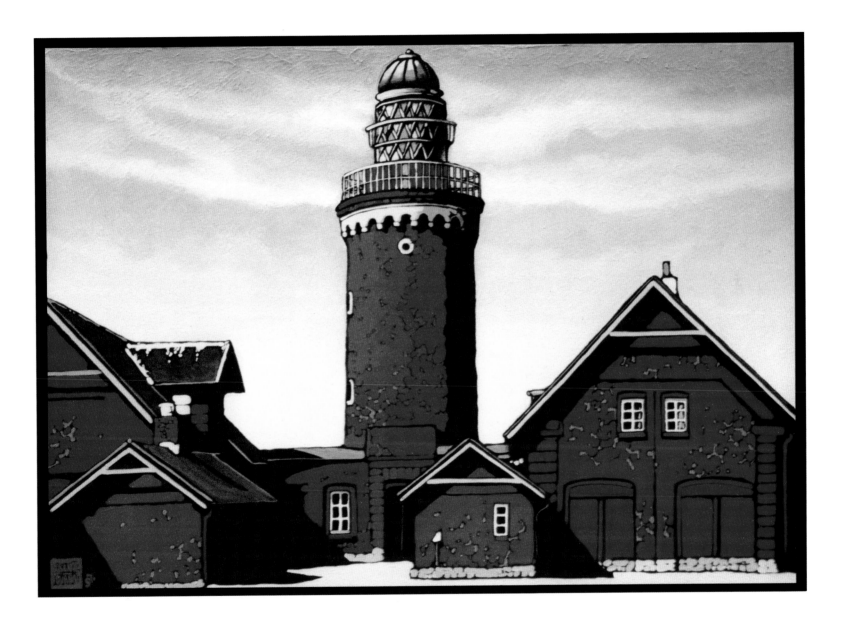

BOVBJERG

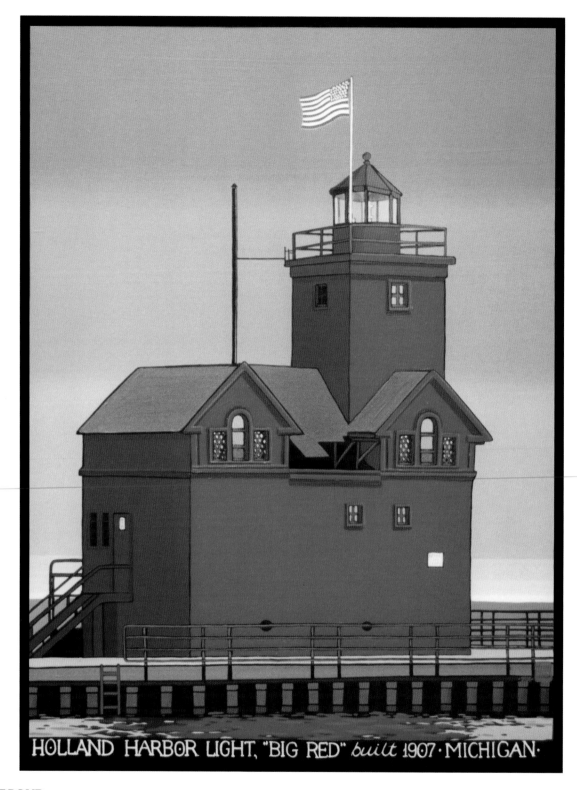

HOLLAND HARBOR LIGHT, "BIG RED" *built* 1907 · MICHIGAN ·

HOLLAND HARBOUR

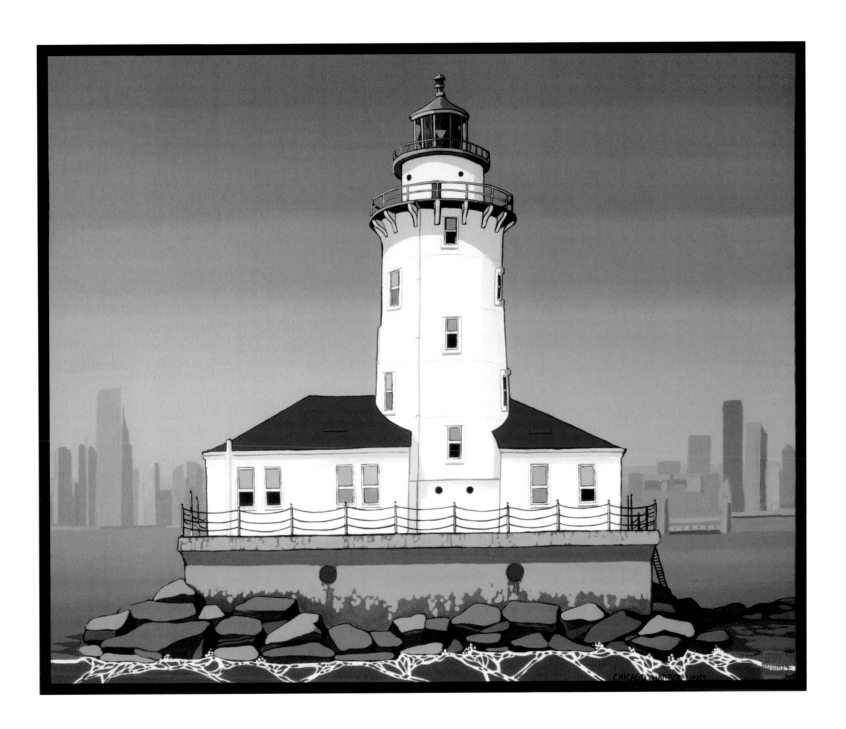

CHICAGO LIGHT

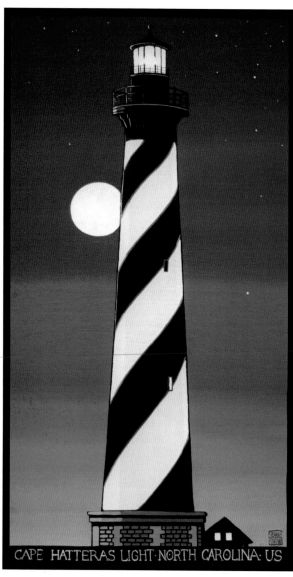

HATTERAS

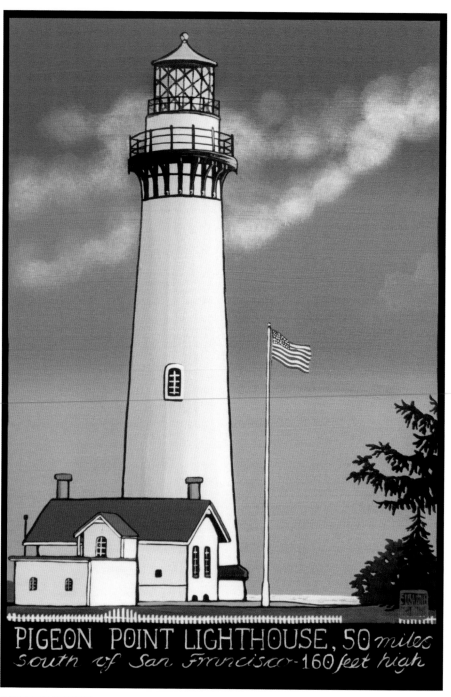

PIGEON POINT

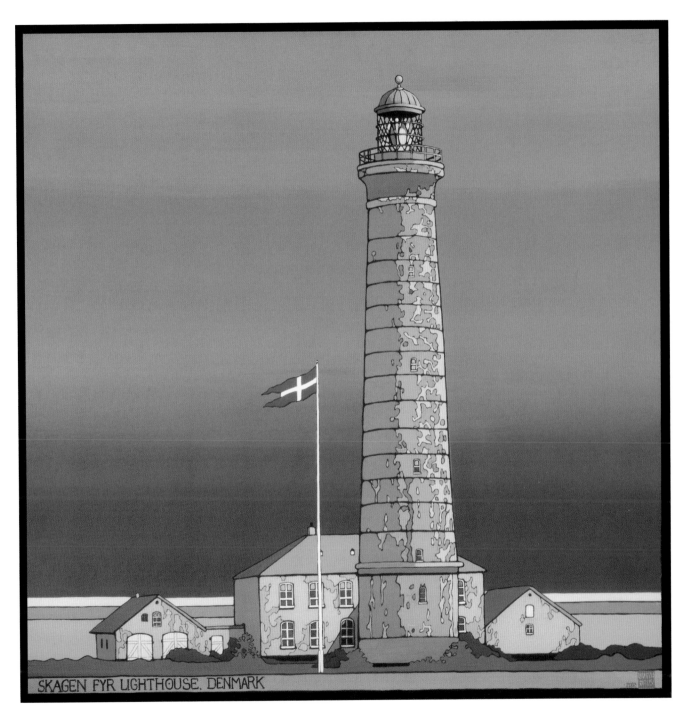

SKAGEN FYR LIGHTHOUSE, DENMARK

SKAGEN LIGHTHOUSE

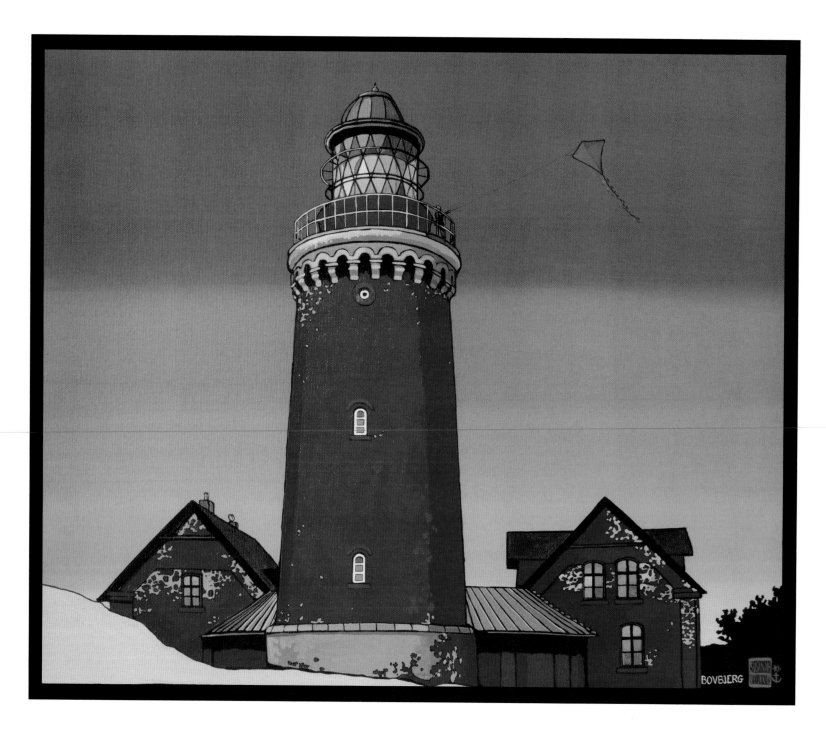

RED KITE

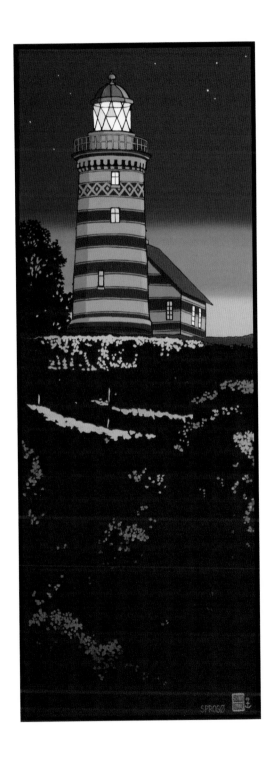

SPROGØ

Wooden boats and yachts

oats have always been made out of wood; at the most basic level, the earliest vessels constructed were carved from wooden trunks, but advancements in shipbuilding resulted in the development of a wide range of vessels. Wood is an infinitely malleable material and as mankind's skill in its use developed through the classical age, so wooden boats became ever more sophisticated: a process that has continued over the past two millennia.

The Vikings became masters in the creation of wooden fighting ships; their sleek vessels easily capable of traversing the stormy North Sea and Atlantic Ocean, bringing dread to the monks of north-east England and colonising Orkney, Shetland the Faroes and Iceland, before venturing to become the first European settlers on Greenland and North America.

The importance of oak in England for naval construction – an aspect musically recalled in the traditional melody *Hearts of Oak* – was such that Acts of Parliament were issued to ensure that trees were carefully husbanded. For example, pollarding was banned in the New Forest by an Act in 1698, to ensure trees of suitable quality were available for naval construction.

Britain has always been a seafaring nation and, until comparatively recently, the only material that these ships could have been constructed from was wood. 'Copper-bottomed' derived from the Royal Navy's use of copper sheeting to cover the hull of its warships in the eighteenth century, a policy which both increased the speed of the ships in question, and protected the hulls from the many sea-borne creatures that would otherwise feast on the timbers.

Fishing boats and all types of working ships were built from wood;

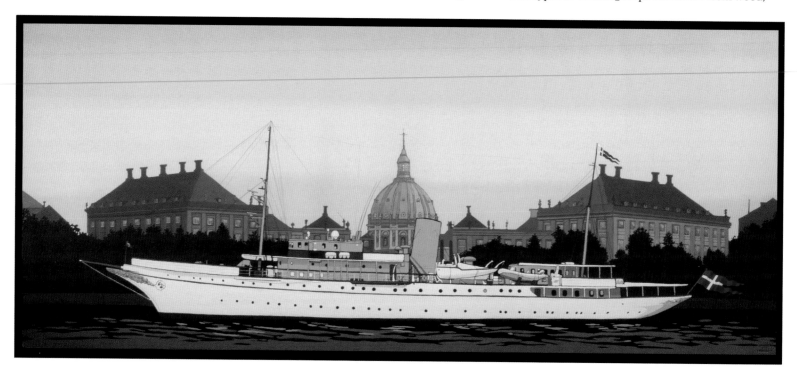

ROYAL YACHT DANNEBROG

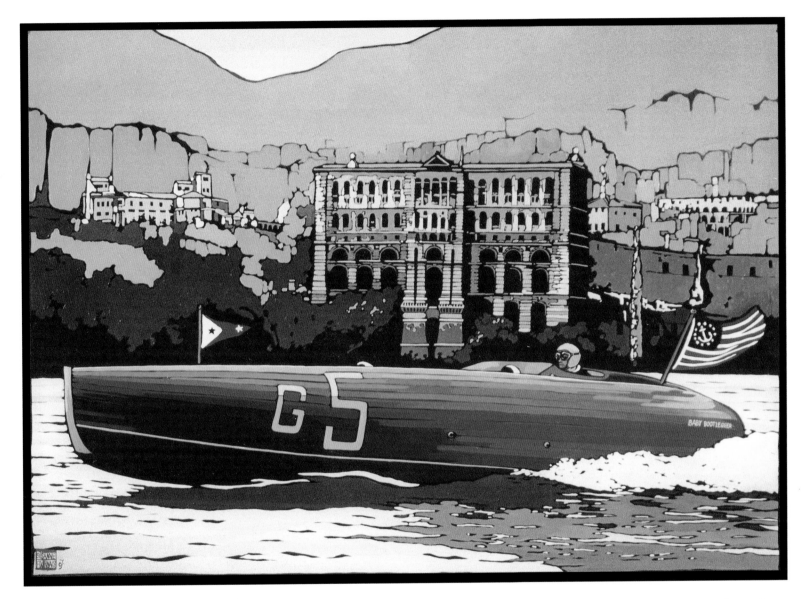

indeed many of the smaller vessels plying their trade around the coast still are. The author remembers well the traditional Danish fishing boats making their way to and from the port of Esbjerg with their traditional red sails visible in the dawn or dusk sun – a romantic picture on a glorious summer's evening.

Yachts and other leisure craft were also traditionally made of wood; the past half-century has witnessed a massive growth in leisure time and with it, a commensurate increase in the number of yachts and cruisers. Many of these can be found moored in the country's historic ports, bringing new sources of income to these communities when the traditional freight traffic has declined. Today, glass-fibre is the most common means of construction, being cheap and durable, but the longevity of wood means there will no doubt be wooden-built boats into the foreseeable future.

MONACO

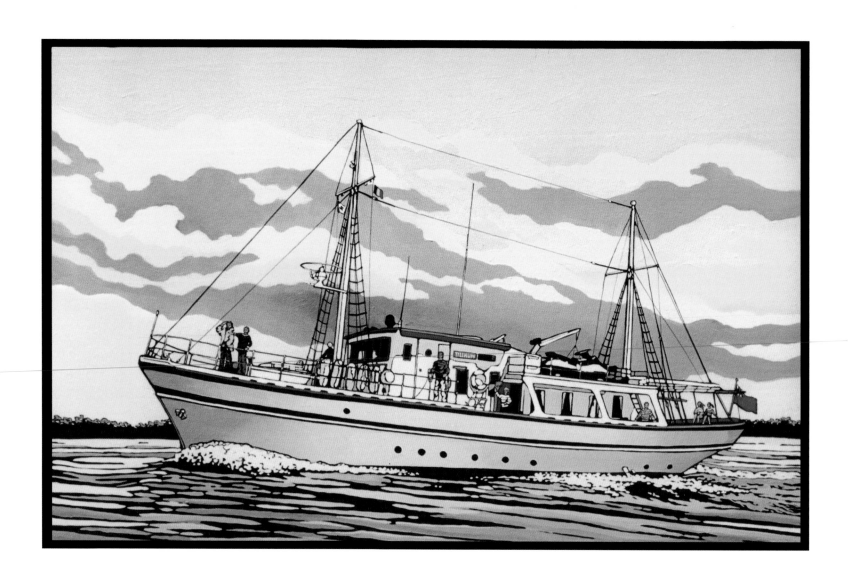

TILIKUM

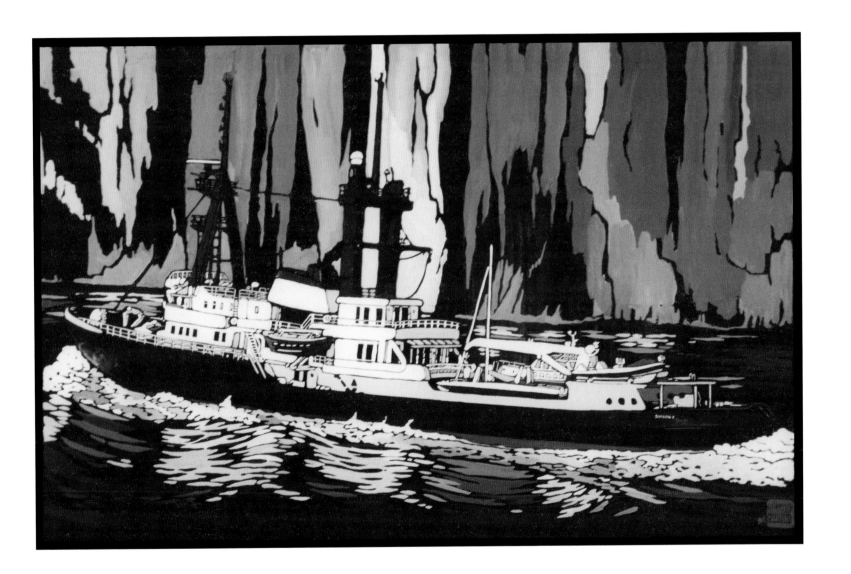

SIMSON S

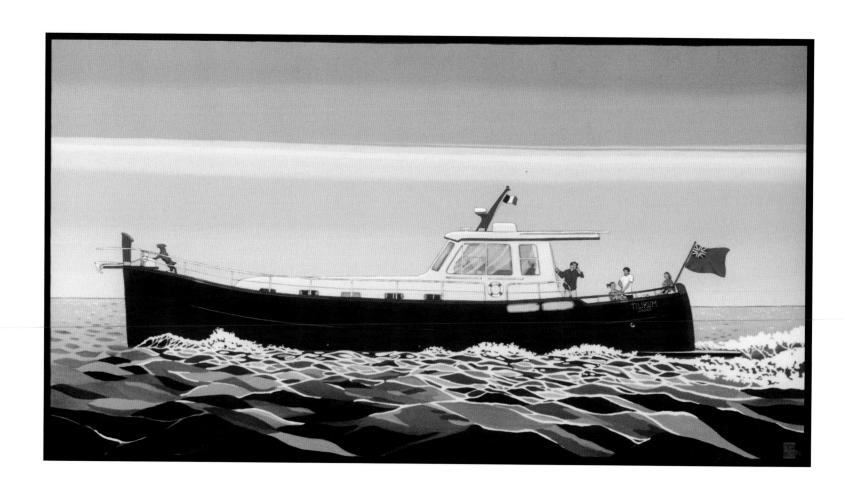

MENORCA

CANNES OLD PORT

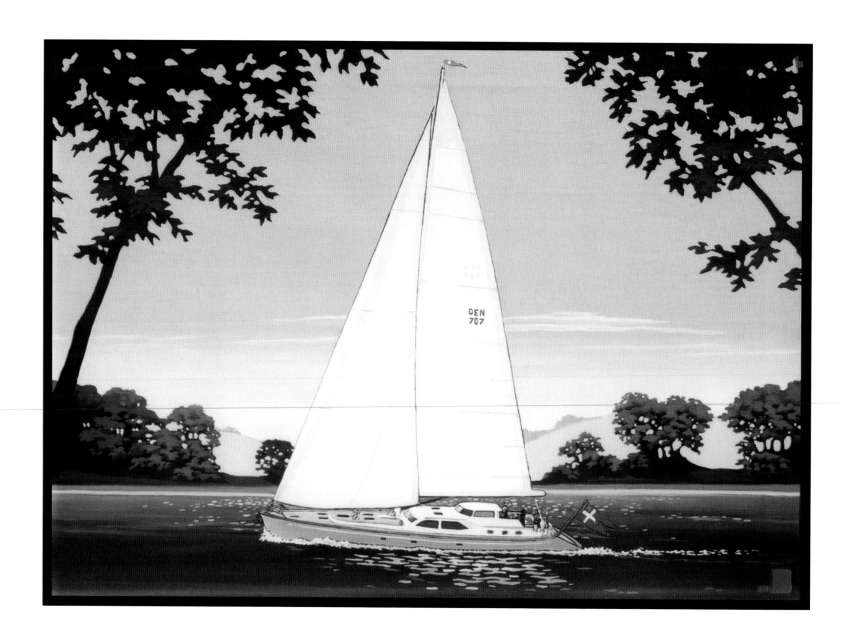

SOUTHERN ISLES

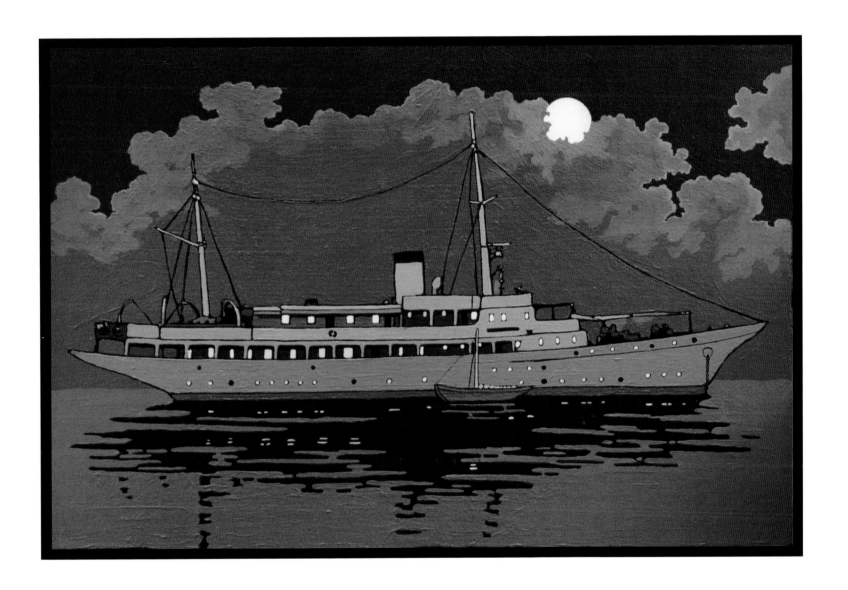

ROSENKAVALIER

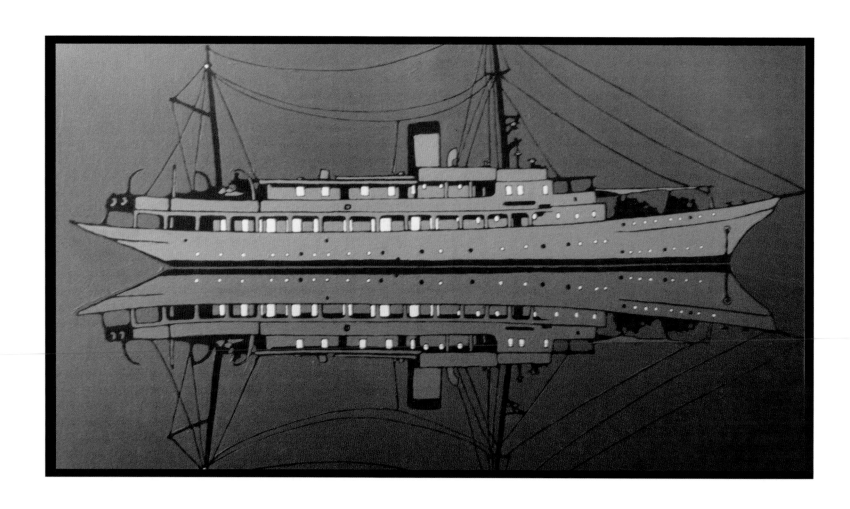

BAY OF CANNES BY NIGHT

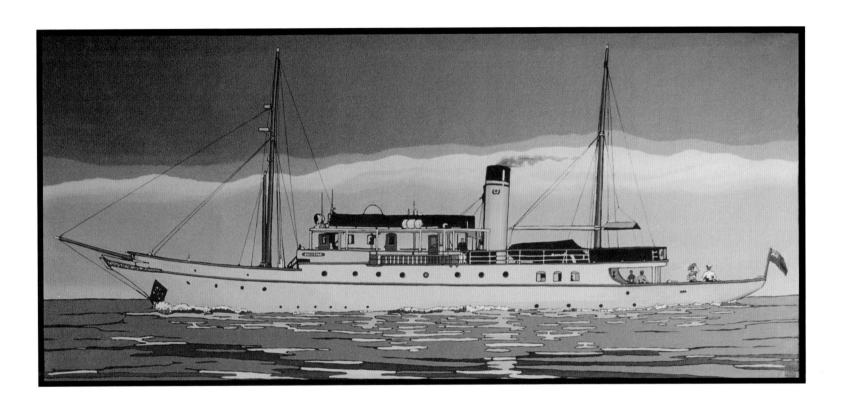

KALISMA

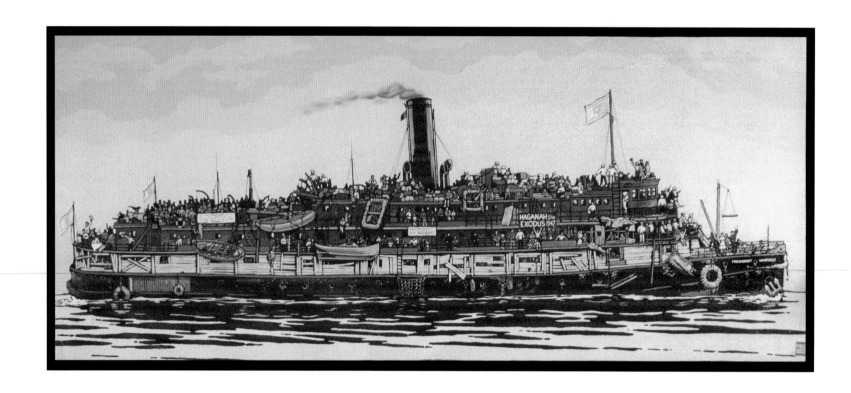

EXODUS

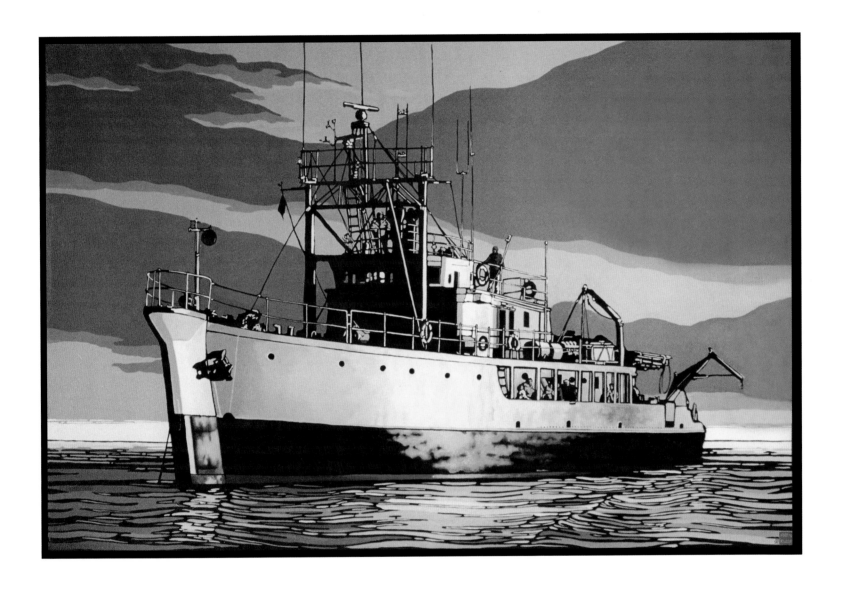

CALYPSO

ØRESUND

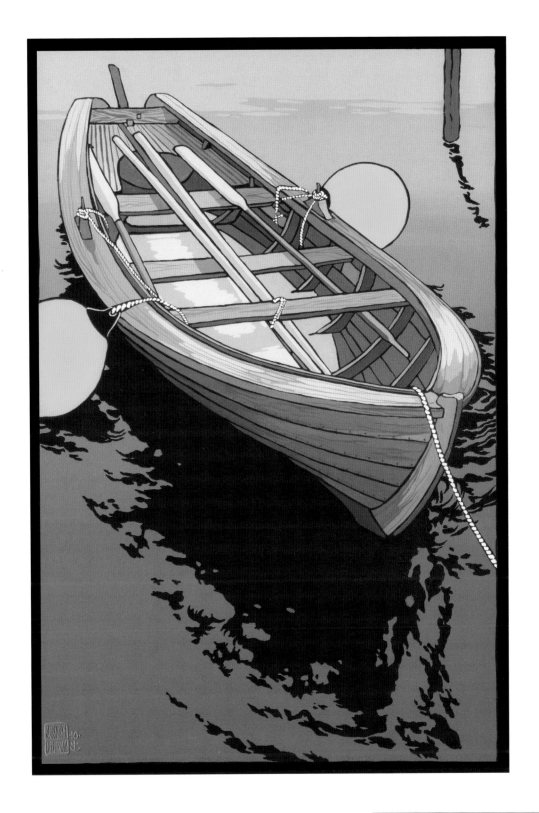

SOFIERO

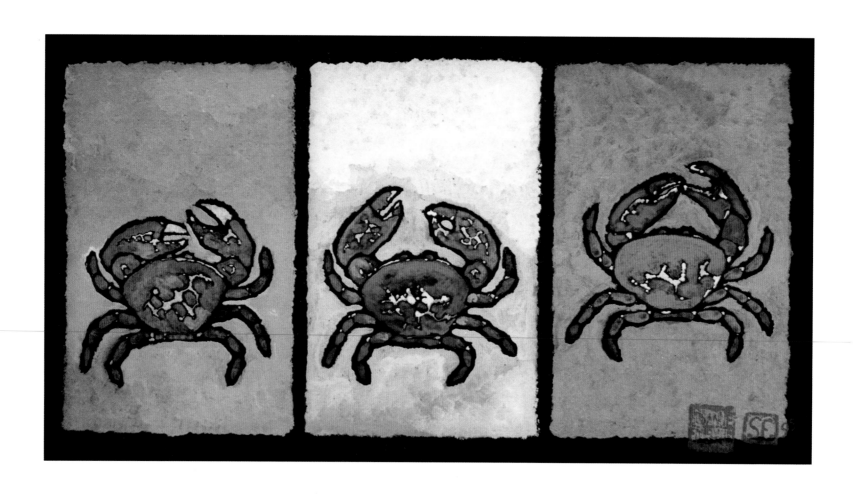

SUMMER CRABS

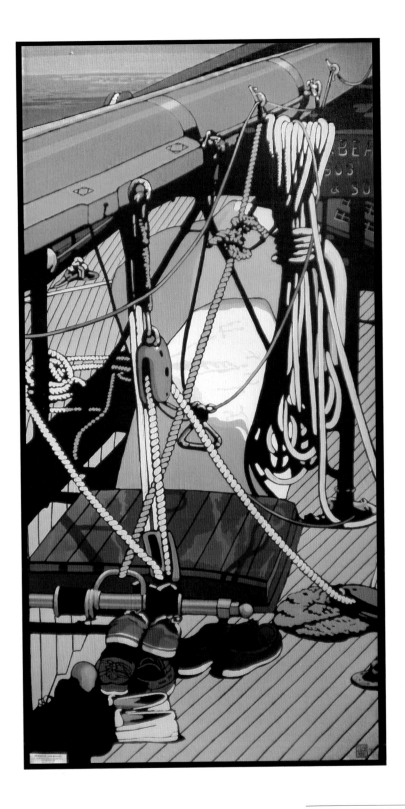

USS ZACA

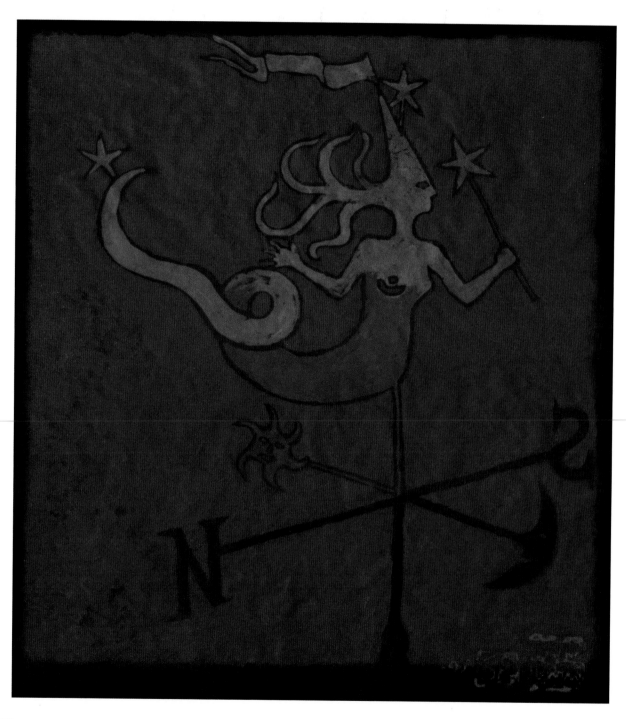

MY MERMAID

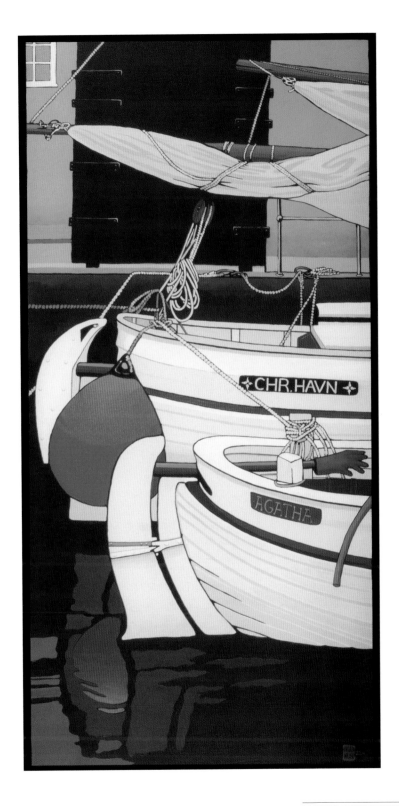

CHRISTIANS HAVN

VEDBÆK WINTER I

VEDBÆK WINTER II

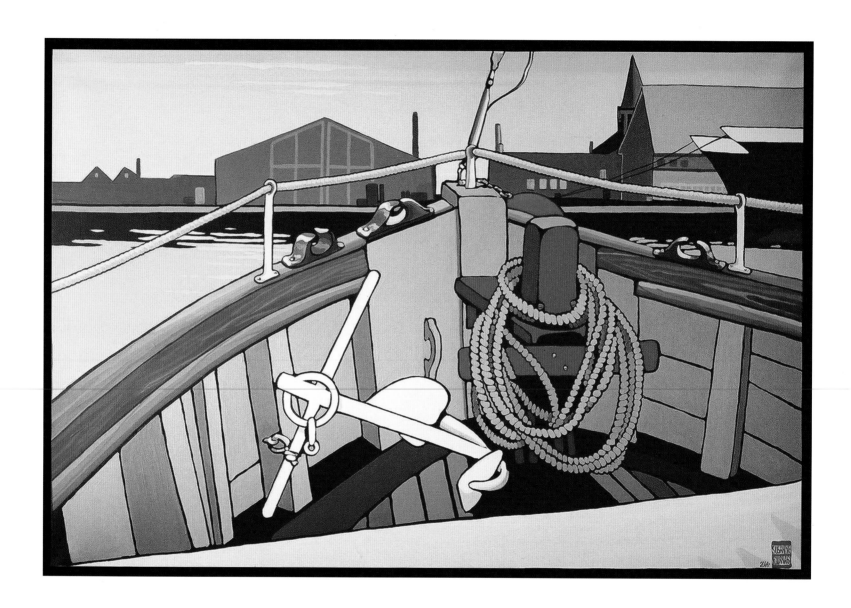

SKAGEN HARBOUR

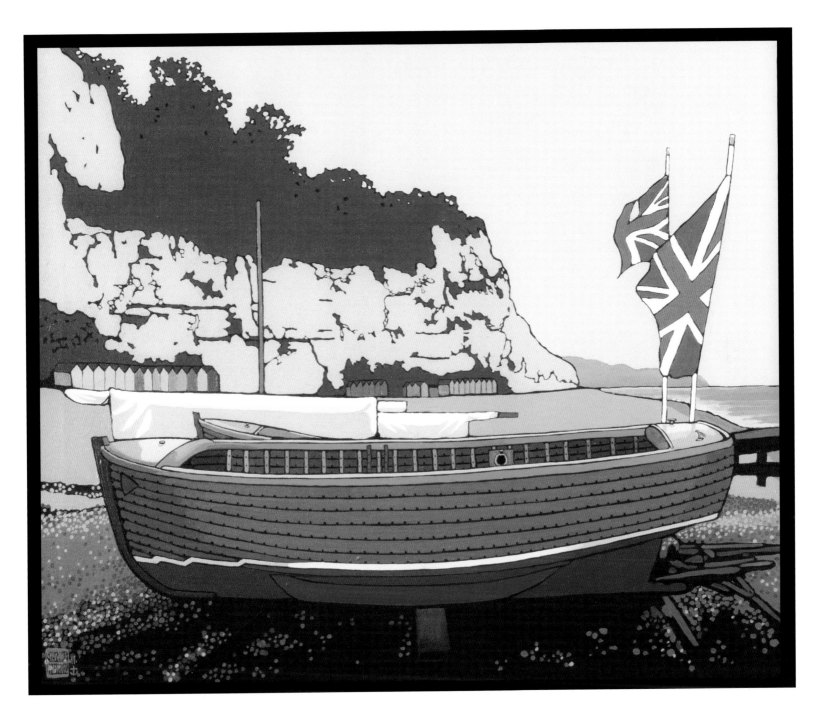

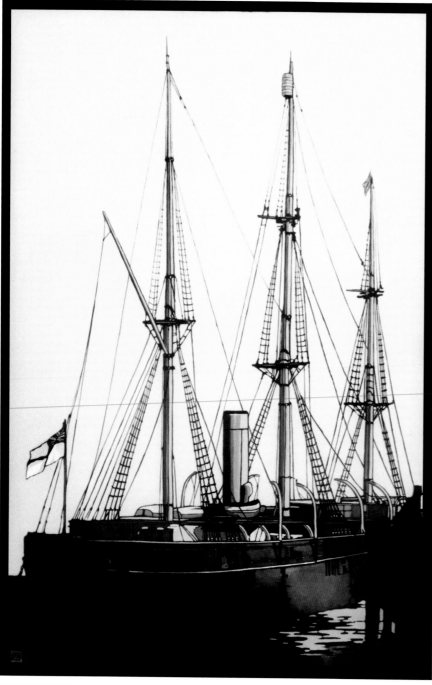

DISCOVERY

RED BUOY

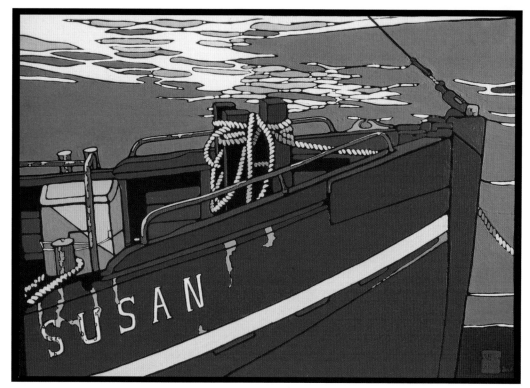

SUSAN

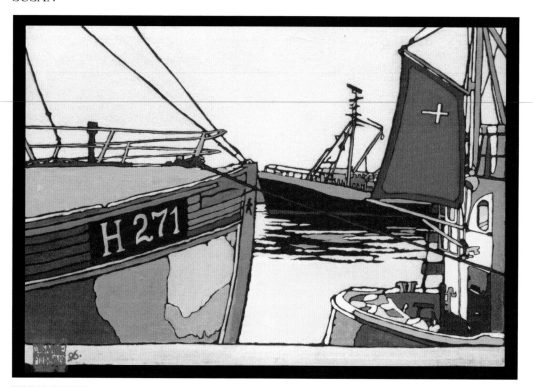

HUNDESTED

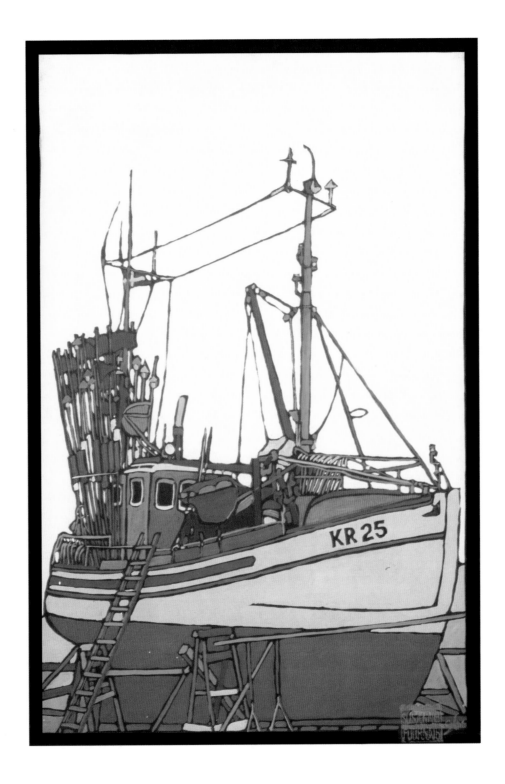

KIKHAVN

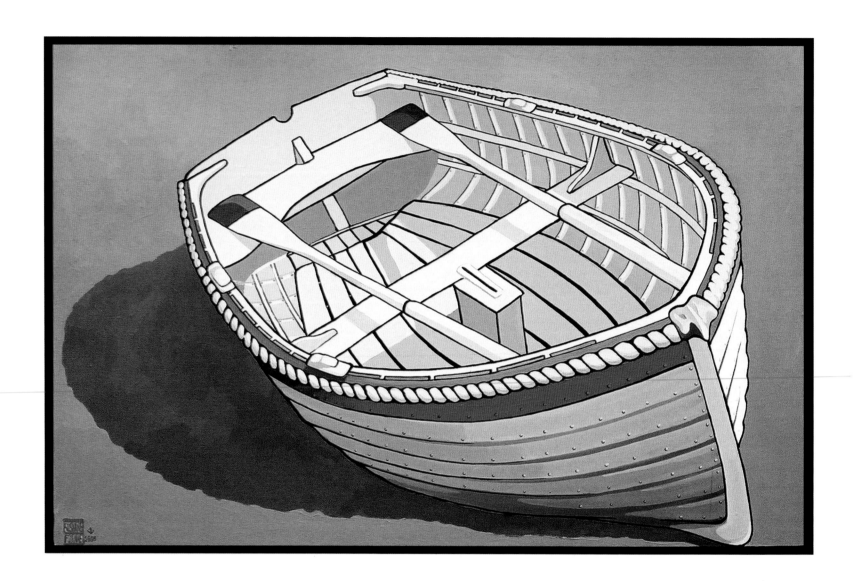

ISLAY

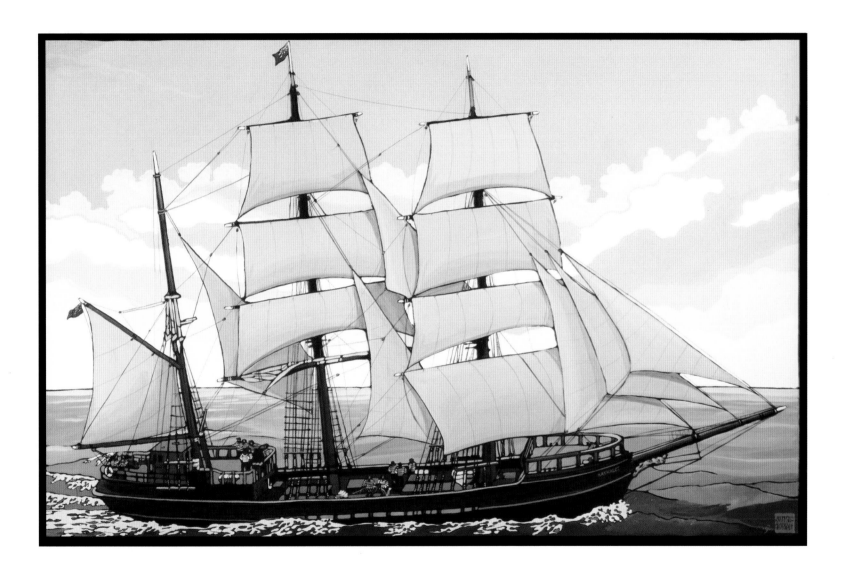

KASKALOT

SUMMER SHELLS I

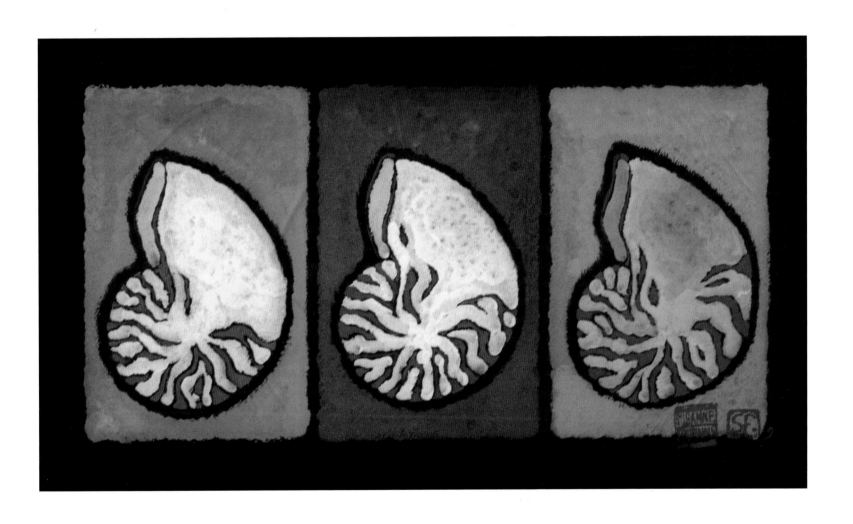

SUMMER SHELLS II

MARIE

Epilogue

After living and working many years abroad in France, Belgium and United Kingdom, Susanne Fournais, has now returned to her native Denmark and settled on the island Aeroe in the southern Baltic sea.

Aeroe has a strong maritime heritage for centuries and many of its inhabitants are still occupied in shipping and off-shore business. The international outlook and the maritime way of life combined with an outstanding nature surrounded by the crystal blue Sea is a constant inspiration for Susanne's artistic work, which she pursues in her distinct precise style of quality and strong colours.

As Geoffrey Hughes from Osborne Studio Gallery in London said at an exhibition in 2015:

'Each boat is painted as an individual portrait of a vessel, either for the beautiful lines or as a piece of glorious history. Susanne's skillful draugthsmanship and sensitive understanding of the boats of her choice, or commissions, were recognized by the title "Official Belgian Marine Artist" in 2004 and allows her to sign her work with an anchor. On her many travels around the world, she almost prefer the voyage and the vessel that brought her safely ashore to the destination itself.'

After exhibitions in Monaco, Germany, Paris, Bruxelles, Ghent, Zeebrugge, Copenhagen and London, Susanne Fournais is pursuing new avenues with her art into the incredible world of ships and shipping.